PAINT
LUXURIOUS
TEXTURES
IN WATERCOLOR

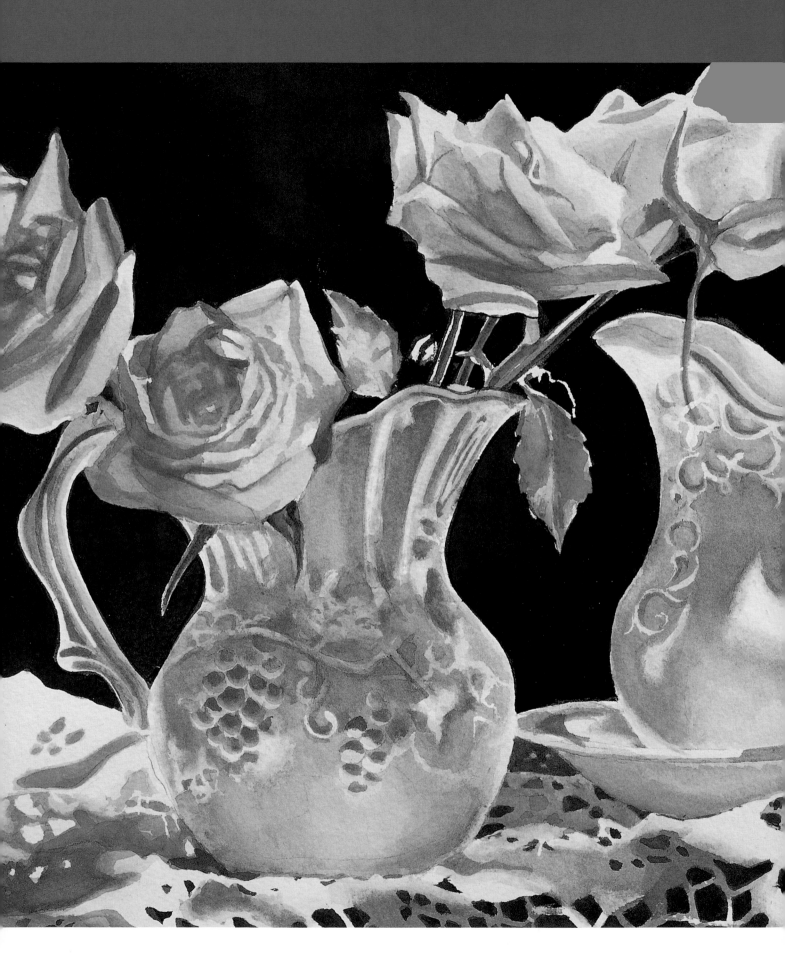

PAINT
LUXURIOUS
TEXTURES
IN WATERCOLOR

JENNIFER SHEFFER

NORTH LIGHT BOOKS
CINCINNATI, OHIO
www.artistsnetwork.com

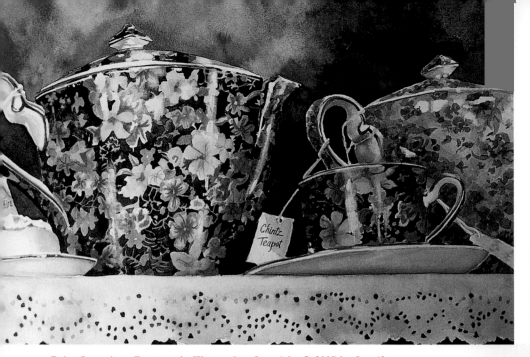

PREVIOUS PAGE: **Yellow Roses**
17" × 12" (43cm × 30cm)

LEFT: **Chintz**
16" × 20" (41cm × 51cm)

Published by North Light Books, an imprint of F+W Publications, Inc., 4700 East Galbraith Road, Cincinnati, Ohio 45236. (800) 289-0963. First edition.

Other fine North Light Books are available from your local bookstore, art supply store or direct from the publisher.

09 08 07 06 05 5 4 3 2 1

Library of Congress Cataloging in Publication Data
Sheffer, Jennifer.
 Paint luxurious textures in watercolor / Jennifer Sheffer
 p. cm.
 Includes index.
 ISBN 1-58180-515-2
 1. Watercolor painting—Technique. I. Title.

ND2420.S53 2005
751.42'2—dc22

 2004057563
 CIP

Edited by Maria Tuttle and Vanessa Lyman
Cover design by Wendy Dunning
Interior design by Marissa Bowers
Interior production by Joni DeLucca
Production coordinated by Mark Griffin

F+W PUBLICATIONS, INC.

About the Author

Jennifer Sheffer began work straight out of high school as a graphic arts assistant for a small ad agency in Virginia Beach, Virginia. Five years later, she began her own graphic arts business. Jennifer used every lunch hour to work on a painting from home. Eventually, her clients began to stop by just to see what she had in progress. After six years and much deliberation, she closed her graphic arts business to become a full-time watercolor artist.

 Jennifer is self-taught and has been painting and drawing since she was a little girl. Her watercolor paintings have been included in a number of important exhibitions, as well as outdoor art shows along the east coast. She has received awards in shows organized by local and national art associations.

METRIC CONVERSION CHART

To convert	to	multiply by
Inches	Centimeters	2.54
Centimeters	Inches	0.4
Feet	Centimeters	30.5
Centimeters	Feet	0.03
Yards	Meters	0.9
Meters	Yards	1.1
Sq. Inches	Sq. Centimeters	6.45
Sq. Centimeters	Sq. Inches	0.16
Sq. Feet	Sq. Meters	0.09
Sq. Meters	Sq. Feet	10.8
Sq. Yards	Sq. Meters	0.8
Sq. Meters	Sq. Yards	1.2
Pounds	Kilograms	0.45
Kilograms	Pounds	2.2
Ounces	Grams	28.3
Grams	Ounces	0.035

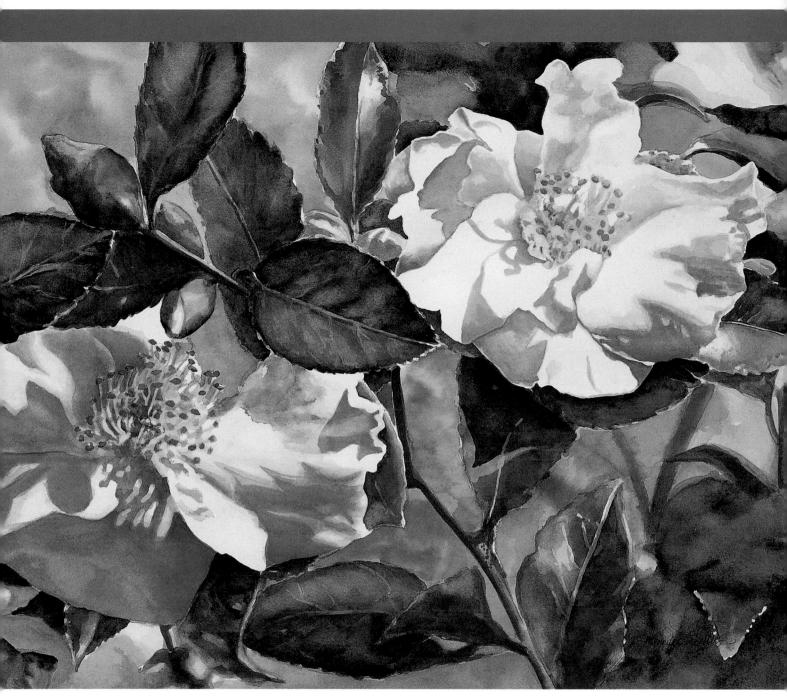

Camellias
20" × 28" (51cm × 71cm)

Dedication
This book is dedicated to my parents. They taught me to be a free spirit, that anything is possible, and to always have a good laugh at myself.

Acknowledgments
I would like to thank Rachel Wolf for giving me the chance to accomplish a lifelong dream. I am also indebted to my editor, Vanessa Lyman, who has given me the freedom to make this book a real expression of my best work.

TABLE OF CONTENTS

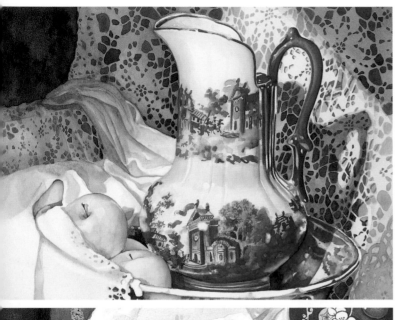

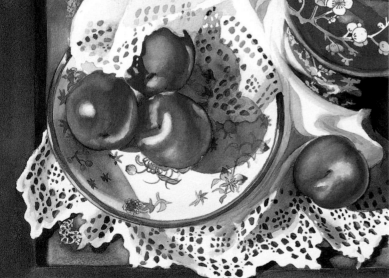

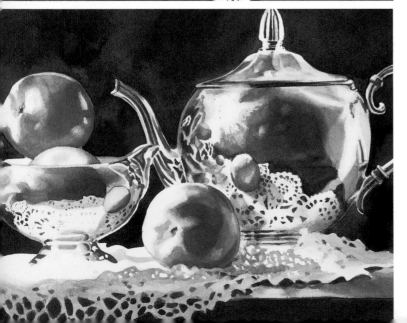

Introduction 9

1 Getting Started 11

2 Design and Composition 19

3 Techniques 33

4 Capturing Light 51

5 Texture
Step by Step 65

6 The Big Picture 109

Conclusion 125

Index 126

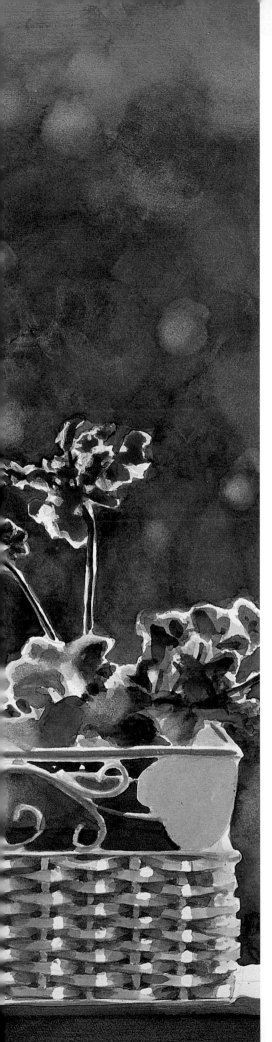

Introduction

Through my life's various pleasures and trials, art has been the one constant.

I became interested in watercolor in particular at the age of thirteen when I

began babysitting at the home of an exceptional watercolor artist, Vonnie

Whitworth. There, I was able to see works in progress and I often marveled at

her ability to handle the medium so delicately. Though she never actually sat

down and taught me how to paint, just being able to see her work in different

stages awakened me to the challenge of watercolor. I hope this book will have

that same silent but powerful influence on you, nourish your confidence and

cause you to set in motion those paintings that you had in mind but have been

afraid to attempt.

Geraniums
17" × 25" (43cm × 64cm)

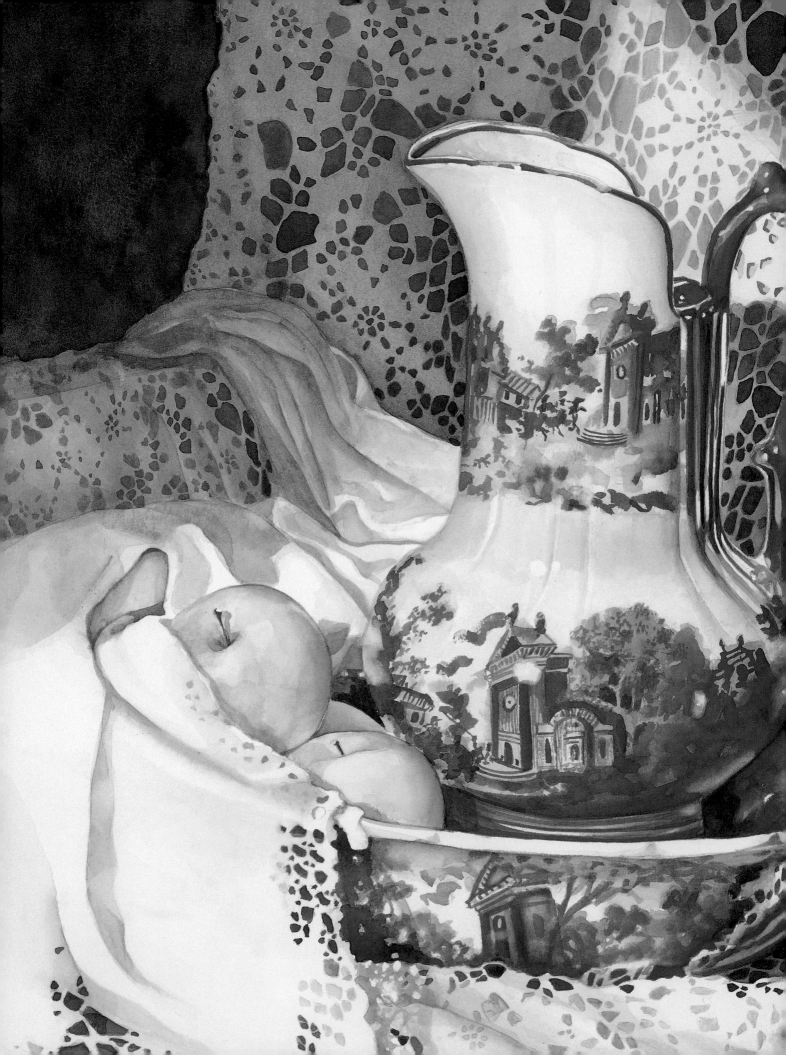

Getting Started

The way great artists make their work look so effortless is due in large part to using the right materials. For example, I can remember buying a pad of student-grade watercolor paper when I was in my teens. I only used one sheet before I discovered the paper's tendency to ripple when wet. The result: puddles of paint settling in the ravines and a very frustrated young artist. Not too long after, a mentor gave me a scrap of Arches 140-lb. (300gsm) cold-pressed paper. The difference was amazing. From that experience, I learned that the quality of materials is the key to great painting, whether it is paper, brushes or paint.

Blue Vase
24" x 30" (61cm x 76cm)

Paints

Watercolor paint comes in many different forms such as tubes, pans and pencils. There is also gouache, an opaque form of watercolor. For the purposes of this book we will be dealing solely with transparent watercolor, preferably from tubes. For vibrant and saturated colors, you will need to buy professional-grade paint rather than student-grade. Student-grade paints are generally gritty and lack intensity.

Paint is separated into several different categories in relation to staining, transparency and lightfastness. Artists will argue the benefits and drawbacks of certain colors, but ultimately you should use the colors that give you the best results.

Choosing Paint

I use six main Winsor & Newton paint colors. The first three are primary (colors that cannot be made from any other color) and the last three are secondary (colors made by mixing primary colors). I prefer the secondary colors out of the tube rather than mixing to create them. I encourage you to experiment and find equivalent primaries that are unique to your painting style.

The Paints I Use

The paints in my studio are all transparent colors except the Cadmium Red.

Winsor & Newton
Quinacridone Gold
Alizarin Crimson
Antwerp Blue
Burnt Sienna
Winsor Violet
Hooker's Green
Cobalt Blue
Permanent Rose
Quinacridone Red
Ultramarine Blue
Sap Green
Quinacridone Magenta
Transparent Yellow
New Gamboge
Grumbacher
Cadmium Red Light
Cadmium Red Medium
Holbein
Opera

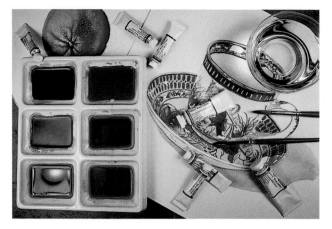

MY PREFERRED PAINTS
I prefer Winsor & Newton professional grade paints. They're available in 5ml and 14ml sizes.

QUINACRIDONE GOLD
By far the most versatile color on my palette, it can even be used in place of yellow. It will not get muddy when mixed with other colors.

ALIZARIN CRIMSON
Depending on the value you use, this color can range from cool pink to deep red.

ANTWERP BLUE
This warm blue is used to push objects into the background and on items that need to be seen in deep shadow.

BURNT SIENNA
I go through this tube faster than any other color. It mixes and layers well with my other base colors.

WINSOR VIOLET
This color is the essence of painting a cast shadow and great for use as an underpainting when rendering dark hair.

HOOKER'S GREEN
An intense green with rich, dark tonal values, it is essential for painting foliage.

Transparency vs. Opacity

Paint can be divided into two categories based on how the pigment works with light on the reflective surface of the paper; paint can be either transparent or opaque. Transparency and opacity have nothing to do with value because both types of paint can go from light to dark. The distinction is in how the paint transmits light. Transparent paint allows light to pass through it to the paper or layer of paint beneath it whereas opaque paint will block the light. Quinacridone pigments tend to be the most transparent, Cadmiums are generally the most opaque. I prefer to work with transparent colors rather than opaque ones because I can get more luminous optical blends of color by layering the transparent pigments. You can't effectively layer opaque colors because you aren't able to see any underlaying colors (unless the paint is greatly diluted). I will occasionally use Cadmium Red Light, for example, but only when a lot of water or another color is mixed with it.

Opaque paints can be used when painting landscapes (something I don't paint) because the heavy pigment only needs one application to render the look of rocks, trees and other rough surface textures found in nature. For a plein air watercolorist, this can be very convenient.

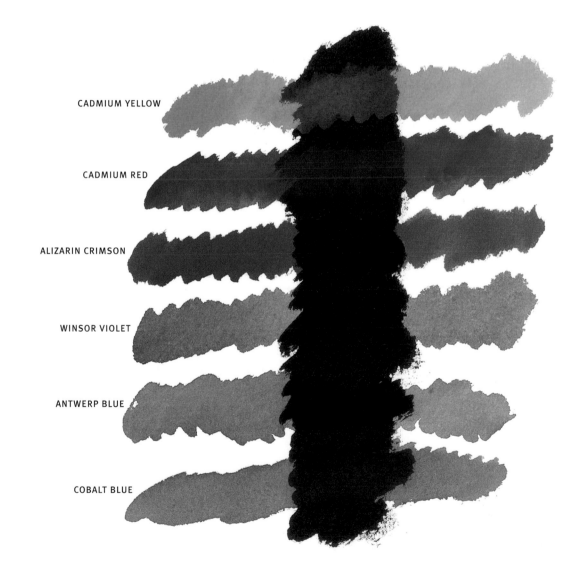

CADMIUM YELLOW

CADMIUM RED

ALIZARIN CRIMSON

WINSOR VIOLET

ANTWERP BLUE

COBALT BLUE

TESTING FOR OPACITY
You can test your paint to determine if it is opaque or transparent by painting the pigment over a dry swipe of black ink. If the color is visible over the black ink (as the Cadmium Yellow and Cadmium Red are here), the paint is opaque. Transparent paints will not show up when painted over the black ink (in this case, Alizarin Crimson, Winsor Violet, Antwerp Blue and Cobalt Blue).

Palettes

There are so many different palettes to choose from. You can find palettes with anywhere from six to twenty-five wells for holding paint. I've even used a plastic ice cube tray as a palette. Ideally, you want a sturdy palette that has deep wells, one or more mixing areas, and a tight lid so that you don't have to re-wet your paint every day.

I use two palettes. When I plan to do a large background, I use the six-welled porcelain palette shown to the right because it holds large amounts of paint and the wells are big enough for the Goat Hair Mop brushes that I use for backgrounds. This palette is fairly compact, which is great because it fits on my desk when I'm working on a big painting.

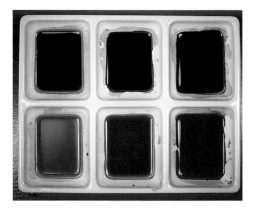

A DEEP-WELLED PALETTE
I use this six-welled porcelain palette when I plan to use large amounts of a color.

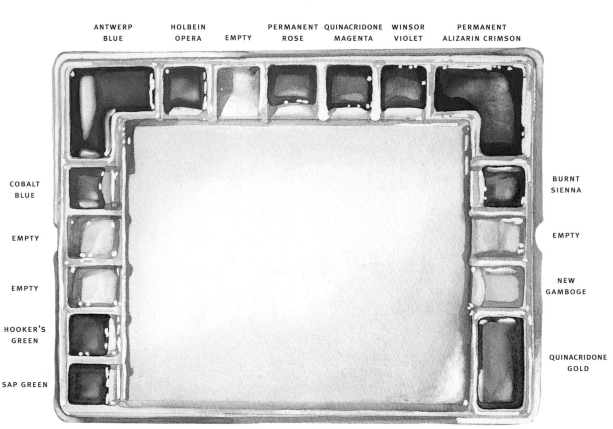

ANTWERP BLUE · HOLBEIN OPERA · EMPTY · PERMANENT ROSE · QUINACRIDONE MAGENTA · WINSOR VIOLET · PERMANENT ALIZARIN CRIMSON

COBALT BLUE · EMPTY · EMPTY · HOOKER'S GREEN · SAP GREEN

BURNT SIENNA · EMPTY · NEW GAMBOGE · QUINACRIDONE GOLD

PLACING YOUR PAINTS IN A PALETTE
This palette is a 12" x 16" (30cm x 41cm) plastic tray with sixteen deep wells and a lid. The lid keeps the paint moist for weeks resulting in less wasted paint. There are three large wells and thirteen small ones. I leave four of the small wells empty for mixing colors, but most of the time I end up mixing in the middle of the palette.

I put yellows on one side, reds along the top, and blues and greens on the opposite side, with the empty wells in between for mixing.

Preparing the Paint

It is important to be organized when preparing to paint. The best way to do this is to have the same paints in the same place each time you work. For example, put warm colors on one side and cool on the other side, leaving a few empty wells in between for mixing.

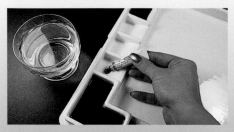

1. Place a pea-size amount of paint in the palette well.

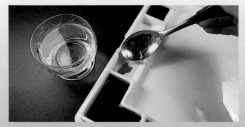

2. Add a tablespoon of clean water.

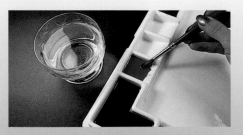

3. Use a clean brush to mix the pigment and water. Wash our brush in clear water before moving to the next color.

Brushes

Finding the right brushes is a process of trial and error. The very best brushes are made of kolinsky sable and are quite expensive. They are worth the money because they have ample reservoirs to hold the paint as well as the snap that artists long for. There are also synthetic blend sable brushes that will keep you just as happy without the expense. I prefer Winsor & Newton brand brushes, notably the Sceptre Gold II Series.

For scrubbing and lifting, I recommend fritch scrubber brushes. They get to the white of the paper faster than a regular brush. Be sure to have a few inexpensive craft brushes on hand for applying masking fluid.

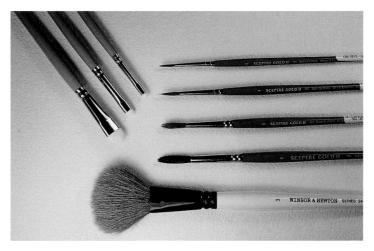

THE BRUSHES IN THIS BOOK
From top to bottom: no. 2, no. 4, no. 6 and no. 8 Winsor & Newton Sceptre Gold II Series round brushes; no. 3 goat hair mop brush. Top left: no. 2, no. 6 and no. 12 fritch scrubber brushes. Fritch scrubber brushes are specifically used for removing unwanted paint from the paper's surface by wetting the brush, scrubbing the point and then blotting it with a paper towel or tissue.

Working With Your Brush

Holding your brush correctly is important when working in watercolor. Be sure that your hand is relaxed. Keep your brush at a 45-degree angle, resting the end of the ferrule on your middle finger.

Using the brush once it is loaded with paint requires some practice. The secret is to let the brush do the work for you as you pull it along the paper. In other words, apply very little pressure as you move the brush back and forth.

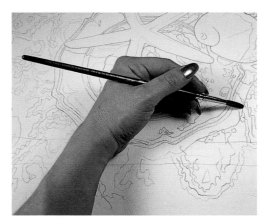

HOLDING YOUR BRUSH
A loose and angled hand position is key when holding a watercolor brush. In this position, the thumb provides stability, the middle finger is where the brush should rest and the index finger controls movement.

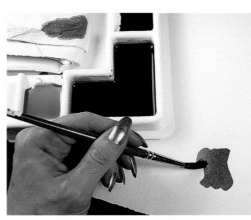

MOVING YOUR BRUSH
Load the brush and blot the excess onto a paper towel. Guide the brush back and forth gently using very little pressure.

When Brushes Shed

Goat hair mop brushes are so loaded with hairs that they tend to shed during the painting process. When this happens, just wait until the area is dry and gently brush the hairs off with a tissue.

Paper

While papers come in different surfaces, weights and sizes, you should always use a paper that's 100 percent cotton rag and acid free. It is up to you to find the paper that will give the best results for your subject matter and technique.

The most commonly used weights are 140-lb. (300gsm) and 300-lb. (640gsm), both of which are available in sheets and rolls.

Most artists stretch their paper before using it to prevent it from buckling but I do not. Stretching involves soaking the paper in water before attaching it to a board. Instead of stretching, I wet the back of the painting when it is finished and weigh it down with a clean piece of cardboard and some five-pound (11gsm) weights for twenty-four hours. To avoid all this entirely, you can simply use 300-lb. (640gsm) weight watercolor paper which shouldn't buckle.

In addition to weights, paper can have one of three different surface textures. The are hot press, cold press and rough.

Hot Press

Hot-pressed paper has a smooth surface, which is ideal for mechanical or architectural paintings. It's also a good surface for airbrushing. This paper allows for more vivid colors and clear edges, but the slick surface makes it difficult to layer washes. To help you remember that hot press is the smooth paper, imagine a hot iron smoothing away all of the texture.

Cold Press

Cold-pressed paper absorbs paint well. It's a very durable paper and probably holds up the best to layered glazes. This durability also makes it perfect for techniques that involve masking, scrubbing or reworking.

Rough

Its name describes it well. Rough paper is a great paper for landscapes because of its craggy texture. When paint settles into the rough paper, it dries unevenly, making natural subjects like rocks, trees and land look more realistic. This paper is good for the wet-in-wet and drybrushing techniques that would be used in creating these subjects.

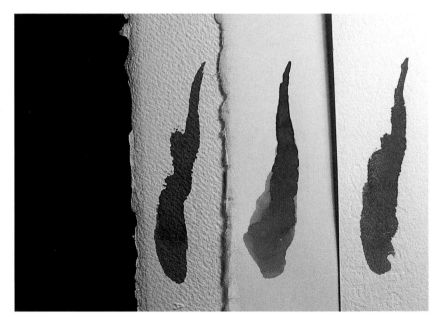

THE VARIETY OF PAPERS
From left to right: 140-lb. (300gsm) rough, 140-lb. (300gsm) hot press and 140-lb. (300gsm) cold press.

Try a Variety

Most art suppliers offer a watercolor paper "sample pack" consisting of several small sheets of varying brands, texture and weight. This is a good way to determine which paper to use without a large expense.

Additional Supplies

Paint, brushes, paper—these are the essential supplies, but there are a few other items that are extremely useful as well.

Masking fluid. Winsor & Newton Art Masking Fluid is my favorite. This is basically a liquid latex that will protect the paper from paint. It will help you to keep control of washes because you won't be spending precious time painting around objects.

For applying the fluid, you can use expendable brushes, a slender knife, the eye of an embroidery needle or a pencil point wrapped with masking tape. To remove masking fluid from your painting, use a rubber cement pick-up eraser (never use your hands).

Hair dryer. If you are the impatient type, you will find that the hair dryer will speed up the drying process, especially when doing a multi-layered background. Hold the hair dryer well above the painting, but don't hold it in one place for long as you might heat up the masking fluid, bonding it to the paper.

Artist's tape. The best tape to use is a 2-inch (51mm) roll of artist's white tape. Any brand will do as long as it's listed as being acid free. This makes the best tool for securing your paper to a fixed surface.

Paper towels. These make excellent blotters for an overloaded brush. They can also quickly lift a wash that you are unhappy with.

Pencils. The preliminary sketch is just as important as the painting. You will need 4H and HB drawing pencils. The 4H is for transferring the drawing from tracing paper to watercolor paper. The hard lead will help to make the lines crisp. Once transferred, you may want to reinforce your drawing with more detail. Use the HB pencil for this. The lines will be easy to see but will not muddy your paint washes like a traditional no. 2 school pencil would. Once your first few washes are complete, you can use a kneaded eraser to erase the pencil lines.

Transfer Paper. It is a waxy, thin paper with a graphite coating on one side that allows you to place it directly on your watercolor paper, graphite side down, and transfer your tracing paper drawing with ease. It comes in single sheets or in rolls. The brand I generally use is Saral Graphite Transfer Paper.

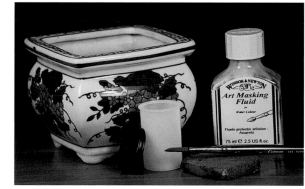

SAVE THE WHITES
Masking fluid helps to secure the white highlights in your painting.

ACID-FREE IS THE BEST
Use acid-free artist's tape to keep your painting in place.

SECURE YOUR PAPER
Tape your paper to a piece of Plexiglas, foam board or light wood leaving a 1-inch (25mm) margin all around for a clean finished edge. I usually work on three paintings at once and this method makes the artwork very portable.



Conserving Masking Fluid

I pour the amount of masking fluid that I will be using for a painting into an empty film canister. This limits the time that my bottle of fluid is open and exposed to the air.



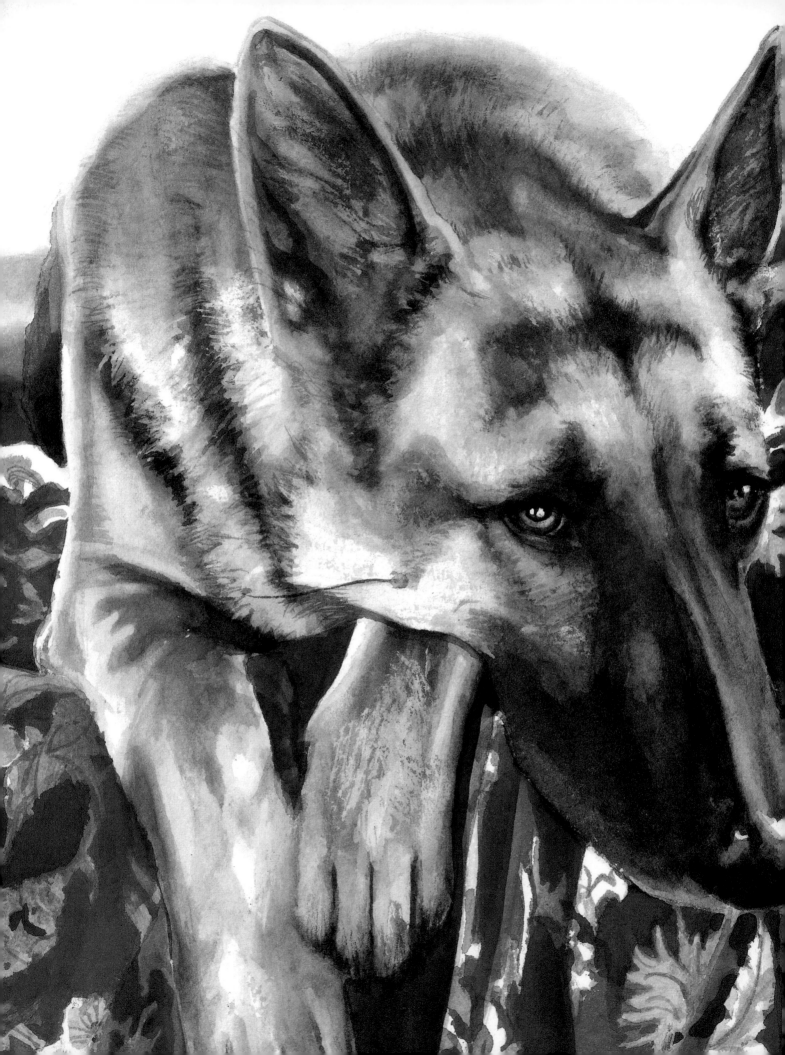

Design and Composition

Take a close look at your life and its components. What do you collect? Paint that. Where do you find the greatest peace? Paint that place. Who is most influential in your life? Paint that person. The painting featured here is my German shepherd, Luna. She's my best friend and is always with me when I paint. The marvelous textures of her fur and her soulful eyes were just irresistible; I had to paint her. I think Luna's character and my admiration for her show in the painting. Choose a subject matter you love and your work will improve exponentially.

Luna
12" x 9" (30cm x 23cm)

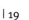

Selecting a Subject

Knowing what to paint and being able to visualize the finished painting involves some introspection and planning. The world around you is teeming with subject matter. Keep your eyes open; frequently your best subject is in the least likely place.

Portraits

The human form is definitely the most challenging thing to depict. I prefer to have my subject looking away from me because a straight-on view of a person's face can appear static. Profiles and three-quarter views of your subjects give the viewer the feeling as if they have happened upon a scene.

Keep the portrait timeless by using clothing, furniture or outdoor settings that can be from any point in time. I have a wide selection of clothes and flowing fabrics that I have accumulated from vintage stores and thrift shops. I have even draped a model in a sheer curtain because I liked the way that it caught the light just enough to hint at the skin tone underneath.

Garden Views

I enjoy landscape paintings, but I see life in terms of detail and texture, something that is best captured up close. The tiny world of a single leaf or petal is as breathtaking as a majestic mountain range to me. If you don't have a garden of your own, go to your local botanical gardens for one of the best subjects: flowers.

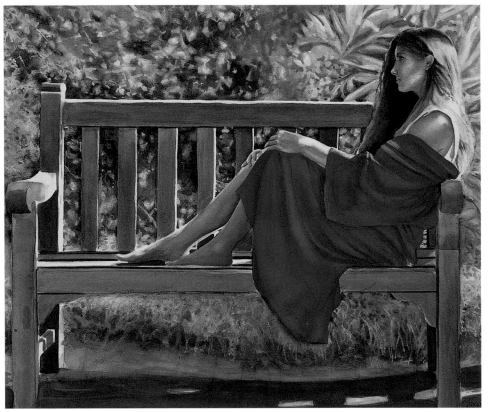

PORTRAIT IN PROFILE

The profile gives the portrait a posed and formal feel, but still gives the viewer the feeling that he or she is peeking in on a beautiful girl who is deep in thought.

Garden Bench
18" x 21"
(46cm x 53cm)

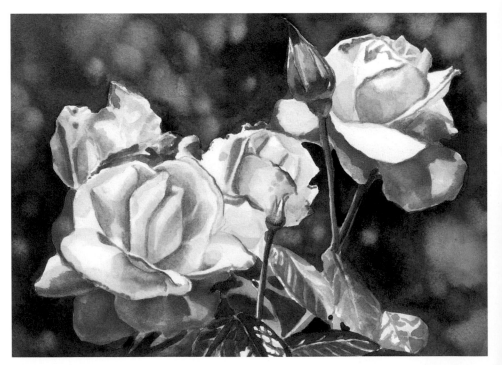

SMELL THE ROSES

The viewer can almost smell and touch the velvety rose petals when he or she is within "nose distance" to the flower.

Tea Roses
8½" x 11"
(22cm x 28cm)

Still Lifes

Arranging a still life is not as difficult as it might seem. It's a good habit to gather more items than you think you need. Having more on hand allows you to play with the setup. You can alter the arrangement without breaking your creative flow to run off for more props.

Beyond their aesthetic or emotional value, the props should also have a compositional purpose. As a rule, I try to have at least one of each of the following:

Cloth. It suggests movement and flow, plus adds a pattern, all of which bring energy to a painting.

Man-made objects such as porcelain, silver or glass. I add these items for texture as well as for the reflection and refraction of light and color.

Organic objects such as flowers, fruits or vegetables. These represent life, add vibrant color and help break up large spaces.

There are a few other tips that can make the process of putting a still life together a little easier.

Repetition. Look for the "echo" of patterns, repeating shapes or compatible colors. Using too much repetition can confuse the viewer, so be cautious.

Natural numbers. When using several of the same organic items such as apples or flowers, include an odd number, like three or five. Excess symmetry doesn't feel natural with organic elements.

Look for light. As you are arranging items, imagine which highlights on the objects will be represented by the white of the paper. These highlights will be the lightest value and will probably attract the viewer's eye, so make sure they are arranged to your liking.

Think about corners. You want to direct the viewer's eye in and out of the composition by placing an object—cloth, for example—in the lower left corner of your painting and provide an exit, maybe by trailing it out the lower or upper right corner. Linear objects can also be used to direct the eye through the painting.

Change your perspective. Stand on a chair to view your still life. Sit on the floor in order to look up at it. You may garner a new idea from looking up at the items from a different vantage point.

Flotsam and Jetsam

As you add and remove items from your still life arrangement, you will find a collection of randomly placed things off to the side. Sometimes they create their own composition that is worth painting.

FIND YOUR SECRET FORMULA
The basic formula for a successful still life is to have at least something organic, something reflective or man-made, and some type of cloth. Varying the size, mass, texture and color of the items will make the painting interesting.

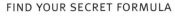

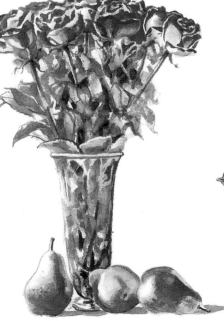

Identifying Shapes

Generally, most items can be broken down into three basic geometric shapes: rectangle, square and circle. Recognizing the shape of things may take some practice, but once you master it, you'll be seeing everything in terms of shape. Apply your new vision by learning to vary the size of shapes that you use when planning a painting.

VARY THE SHAPES
Most objects have an inherent shape. If you use at least three different shapes in a painting, you will create the variety required to keep the viewer interested.

Simplify By Squinting

This is a trick that artists throughout the ages have used to help them "see" more objectively. Squint or unfocus your eyes and you will notice that the objects around you are broken down into basic shapes, blocks of color, and dark and light values. This helps the process of creating a good composition by forcing you to use shape and value as your guide instead of being distracted by the identity and detail of the objects.

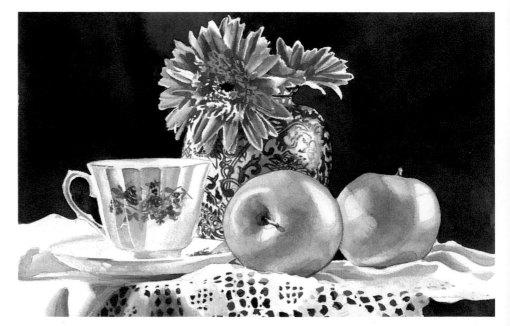

SHAPES WITHIN SHAPES
In this painting, there are shapes within shapes. On the most basic level, both the apples and daisies are circles, the teacup is a square and the vase is a rectangle.

Tea With Daisies and Apples
11" x 14" (28cm x 36cm)

Using Negative Space

Positive space is the actual mass of the object you are painting. Negative space is defined as the space existing around the object or between two or more objects, but it can also exist on an object, usually as shadowed areas. Look for negative space on your subject and make the most of it; it benefits the composition by giving the viewer's eyes a place to rest in the same way that a pause in a piece of music gives a moment for your ears to rest.

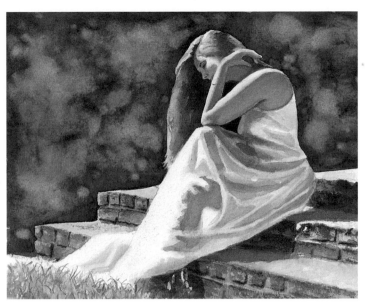

NEGATIVE SPACE ON YOUR SUBJECT
The three triangles of negative space provide a subconscious balance to the painting and the negative space on the subject's arm and face help to model the form.

Diana
6" x 8"
(15cm x 20cm)

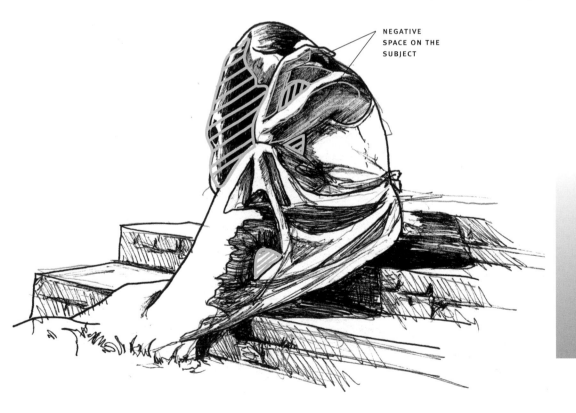

NEGATIVE SPACE ON THE SUBJECT

Allow the Eye to Rest

The busier the composition, the more negative spaces you will need in order to keep the painting visually peaceful. The negative spaces give the viewer's eye several places to rest along the path through the painting.

Create Balance

Balance in artwork is a principle that helps create visual weight in a composition. For example, it is best to have one dominant shape or "heavy" object surrounded by several smaller objects to give the feeling of equal weight. Balance can also be created by the unity of shapes repeated throughout the composition, sometimes referred to as a "visual echo." You can also use contrasting colors and textures to create balance.

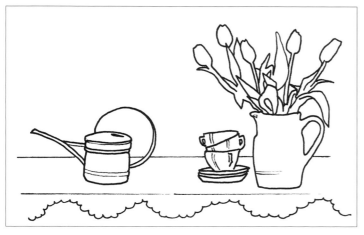

BEFORE

The composition is too heavy on the right and the spout of the watering can is facing out of the picture.

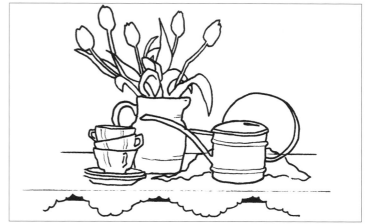

AFTER

The largest object is now more central and turned to face the watering can. The teacups and the watering can are the same height, so they are placed on either side of the vase. Each item overlaps the other in some way to connect all of the objects.

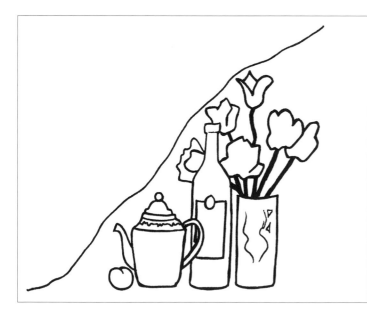

BEFORE

The vase and the wine bottle are too similar in mass and the teapot spout is facing out of the picture. The diagonal line of cloth in the background creates a visual jail for the other items and causes the upper left to become dead space.

AFTER

The shape of the vase has been changed to add more variety. The teapot is now facing into the picture. The cloth is still in the same position, but the vase of flowers and the wine bottle break out of the diagonal to fill what was once dead space.

Add Depth

When objects in a composition are lined up right next to each other, the result is a very flat and uninteresting painting. Placing your objects on different planes (foreground, middle ground and background) will give the illusion of depth and space. Layer your space by overlapping shapes on different planes to link them all together. By doing this, you provide a visual path though the painting for the viewer to travel. The negative spaces you included between and around objects give the eyes a place to rest. The objects in a painting need to look like they are having a conversation with each other.

NO DEPTH
Here is what the painting would look like if all of the objects were placed on the same visual plane. The objects have no relationship with each other and the painting has no depth.

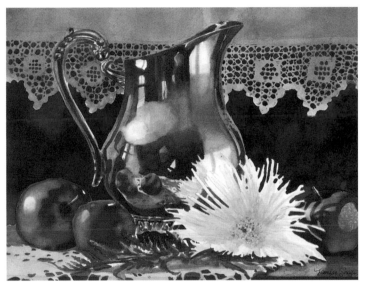

WHEN OBJECTS ARE ON THE SAME PLANE
When you are showing a grouping of identical items on the same plane, you can create depth by adding a patterned background or by making the background out of focus. When you look at landscape paintings, for example, the distant objects are less distinct and show less detail because they are further away from the viewer.

Silver and Apples
11" x 14"
(28cm x 36cm)

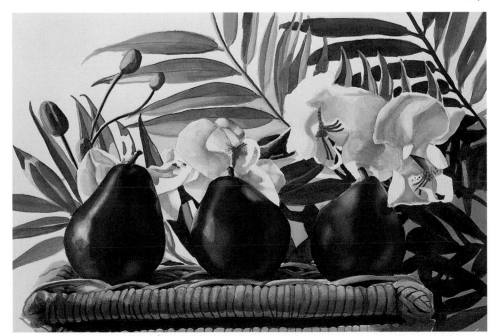

MAKE IT INTERESTING
These three pears are all on the same plane but the painting has depth because of the fronds and orchids in the background.

Three Bosc Pears
10" x 16" (25cm x 41cm)

25

Rule of Thirds

Composition is really a matter of dividing space. The rule of thirds is a guide artists have used for centuries in order to arrange space and objects on their canvases. It's fairly intuitive and is an easy concept for a beginner to learn. Basically, people find an off-center image more aesthetically pleasing that a perfectly centered one. Rather than divide your paper in half and placing the focal point in the middle, divide the picture into thirds (both horizontally and vertically) and place the center of interest at any of the four intersections.

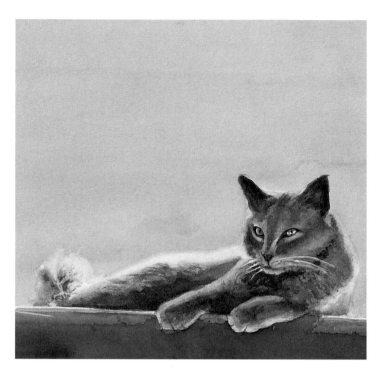

LOW HORIZON
The composition is made more pleasing by placing the cat in the lower third of the painting rather than directly in the middle.

Ashes in a '53 Cadillac
9" x 7½" (23cm x 19cm)

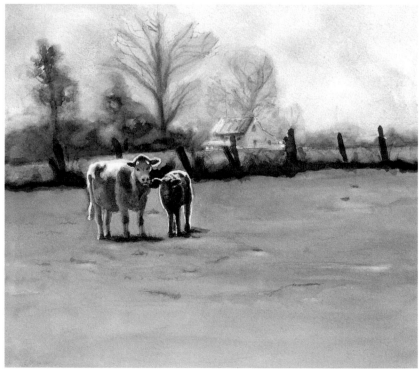

HIGH HORIZON
The high horizon and the upper left positioning of the focal point brings your eyes directly to the cows.

Suffolk Cows
9" x 8" (23cm x 20cm)

Find the Center of Interest

What do you want your viewer to see first? That should be the center of interest in your composition. The way in which you position your focal point is crucial. Arrange your composition so that other items are in some way pointing to your focal point either physically or by an extreme difference in mass, color or texture.

Shifting the Focus

Crop your reference photo in various ways to create different focal points. I often do this if I want to redo a painting, but in a slightly different way. I cut a small square or rectangle out of paper and move it around over my reference photo. I can usually find a completely different and sometimes surprising focal point this way.

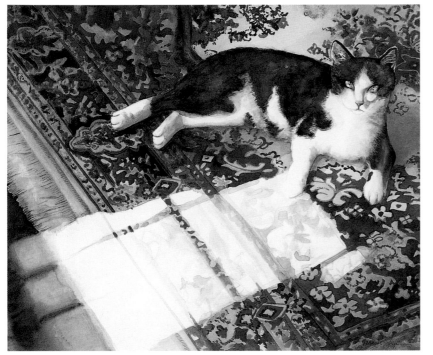

VARY THE TEXTURES

The cat is made the center of interest by the direction of the sunbeams. The cat also becomes the focal point because of the contrasting textures of smooth cat fur with the rough pile of the wool rug.

Luxury Cat
14" x 19" (36cm x 48cm)

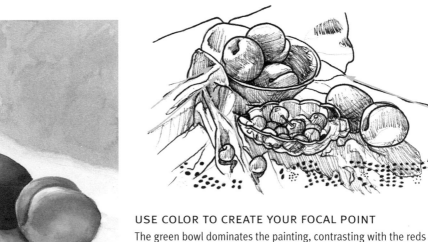

USE COLOR TO CREATE YOUR FOCAL POINT

The green bowl dominates the painting, contrasting with the reds and oranges of the fruits. The folds in the cloth create movement and direct the viewer's eye into the the painting, up to the green bowl, around the middle and back out again.

Nectarines and Cherries
9" x 12" (23cm x 30cm)

27

Vary the Format

Some subjects simply look better in one format or another based on their shape. The grouping of items or people will also help you determine the format.

A grouping of many objects requires a horizontal format, just as you would take a panoramic or horizontal photo of a grouping of many buildings. This is sometimes referred to as a landscape view. A vertical format, also called portrait view, is the preferred shape of a final painting when the subject is a person sitting in a chair, a tall tree, or a single object such as a vase or planter with flowers in it.

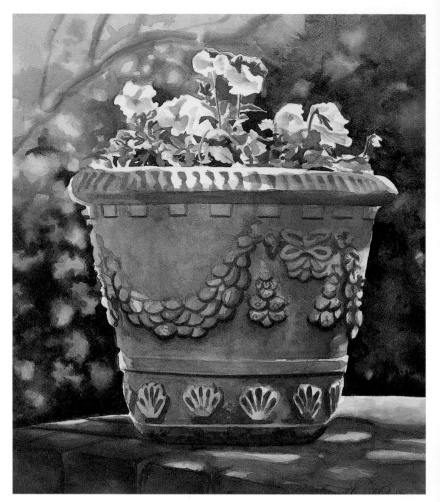

CONSIDER THE SHAPE
The overall shape of the planter and pansies is a tall rectangle, so the format of the painting is determined to be vertical.

Pansies
14" x 11"
(36cm x 28cm)

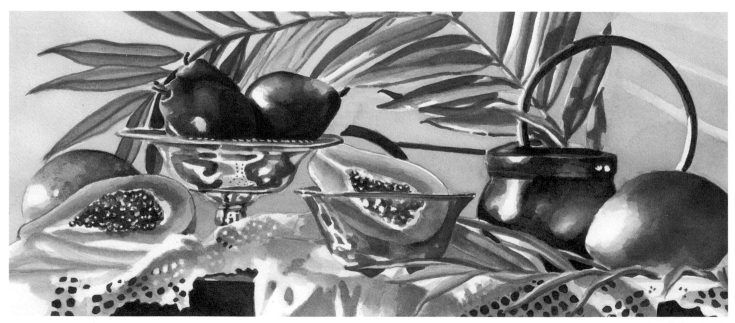

HORIZONTAL
Also called landscape, the horizontal format is best used when you have many objects or a reclining animal or person to paint.

Tropical Fruit
7" x 17"
(18cm x 43cm)

Engage the Viewer

We see things at eye level, so it makes sense for a painter of realism to recreate that perspective. You want to subtly bring the viewer into the painting. You also want to give their eye a path through the painting, places to rest and opportunities to travel back out. You might do this with directional lines from flower stems, cloth or the shape of the focal point.

You can also engage the viewer through the relationships of the still life objects to one another and to the space around them. In the painting below for example, the teacup overlaps the teapot; this helps carry the eye from one item to the next and adds a spatial element. I like to have items overlap one another in order to create one large "shape" in the final painting. In most cases, this shape is a triangle, as in the painting below. The viewer sees this large mass first, however subconsciously, and is then brought into the painting by the intersection of overlapping items.

An Overhead View

Consider using an overhead composition when your focal point is round object such as a bowl or a basket. The perfect circle provides a frame for the painting, inviting your viewers to consider the items within the circle.

The overhead view is also great when doing a floral subject, especially when it is an extreme close-up. The flower turns into a beautiful abstract of patterns and shapes.

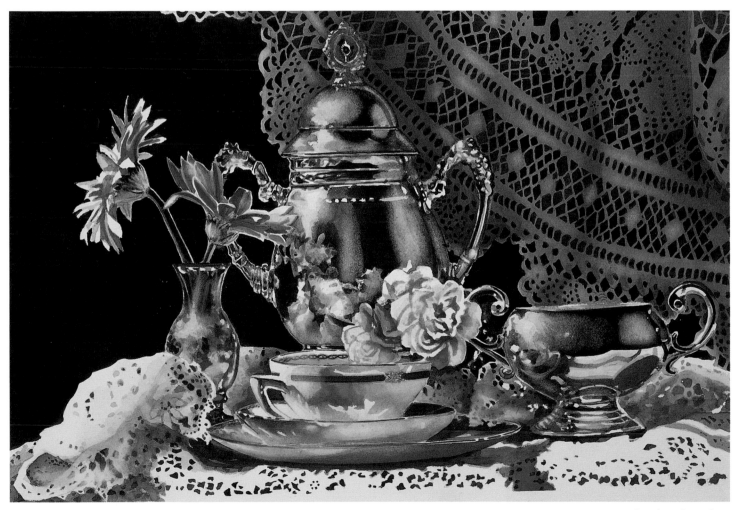

EYE LEVEL PERSPECTIVE ALLOWS FOR A FORMAL COMPOSITION
At eye level, the collection of objects form a triangle to lead the viewer through the painting.

Graduation Cup
13" x 20" (33cm x 51cm)

Composing With Found Images

Load your camera with 400ASA film and keep it with you when you go out. You may find an intriguing flower, building, or person in your daily routine and your camera will help you to capture the moment.

Most shop owners don't mind if you take a few pictures as long as you don't interrupt the flow of traffic into their businesses. Politely explain that you are an artist taking reference photos. I have begun wonderful friendships doing this. Some people have even been gracious enough to lend me precious pieces from their private collections to photograph and paint.

Good Reference Photos

Reference photos are intended to serve as basic cues for light, form and color. You must use your own artistic vision once you sit down to paint because colors and perspective in photos are usually inaccurate.

I recommend buying an SLR (single lens reflex) camera and tripod. This camera usually comes with a 50mm lens, but you may also want to invest in a 70mm-100mm lens for zooming in on more detailed subjects such as flowers and leaves.

The best film to use for still life arrangements is 200ASA print film. This ensures a crisp photo without grain. If you plan to use your camera without a tripod, you can use 400ASA film and still get decent reference photos. I use the 400ASA when I venture outside to find blooming flowers and when I travel to botanical gardens.

Take many photos of the same scene and from different angles. The more information you have, the better your painting will be. I also like to note the season and time of day of each shot on the back of the picture.

If a photo doesn't impress you right away, don't throw it out. Put your photos in a file, because one day, you're sure to find them and wonder, "Why didn't I paint this years ago?"

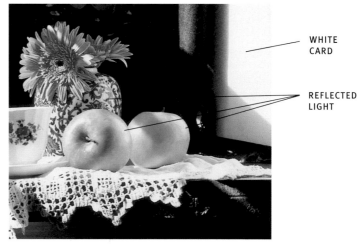

WHITE CARD

REFLECTED LIGHT

WHITE FOAM BOARD
Use a piece of rigid white foam board to reflect light back into the dark areas of your composition. Notice the bright highlights on the left side of the apples and vase.

CROPPING FOR IMPACT
Nothing says you have to use the entire photograph as your painting. Consider using only a portion of the photo as your entire painting, and crop out the rest. Cropping works especially well when painting floral subjects. The result often is a more dramatic composition that forces the viewer to first see color and pattern before realizing the subject is a flower.

Here, I cut the shape of a square or rectangle out of the middle of a piece of paper and moved it around on top of the photo until I found something that interested me. Then I cropped the image and used that as my reference photo.

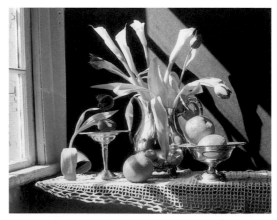

BLACK FOAM BOARD
If you have several light objects in your composition, a dark background will define their outlines. I also use the black card when I'm planning to paint a dramatic dark background.

Transferring an Image

In order to transfer an image from a photo to your paper, first draw the entire image to scale on a sheet of tracing paper with an HB pencil. By using tracing paper, you can erase and rearrange as much as you need without marring the surface of your watercolor paper. When you're pleased with the composition, place a sheet of graphite paper between the tracing and the watercolor paper, then use a 4H pencil to lightly go back over your line work. The 4H pencil has a very hard lead, so take care not to press too hard; you might leave a "dent" on your paper.

Capturing the correct scale is simple once you learn the trick of using a proportion grid. I draw a grid of half-inch squares on my reference photo. Then, I reproduce that grid at a larger scale on my paper. I draw what I see in the reference photo's squares into the larger square on the paper. This method is excellent for really breaking images down into easily drawn shapes.

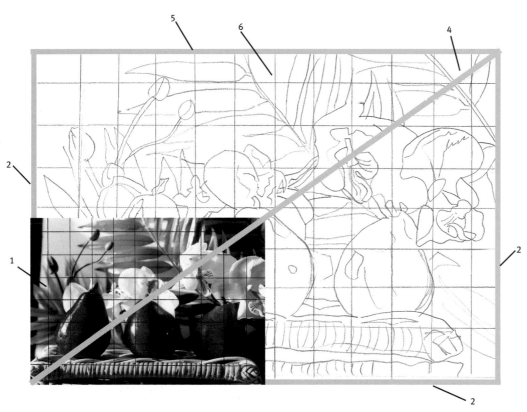

Using a Projector

I enjoy drawing, but if you're eager to paint and don't want to spend valuable time drawing, you can use a projector. Tape a piece of watercolor paper to the wall and then project your image onto it. Use an HB pencil to draw directly onto your paper.

DRAWING WITH A PROPORTION GRID

This is a technique you can use to ensure that your drawing is an exact ratio enlargement of your reference photo.

1. Use a marker to draw a grid pattern on your photograph. For a photo of 4" x 6" (10cm x 15cm), a grid of ½-inch (13mm) squares will be enough to create a line near each major point of the drawing.

2. On a piece of tracing paper, use a straightedge to draw lines indicating the left, bottom and right sides of the painting.

3. Place your reference photo in the lower left corner of the tracing paper.

4. Using your straightedge, draw a diagonal line from the lower left corner of your photo, through the upper right corner of the photo and all the way to the upper right corner of the paper.

5. Draw a line from the left side to the right side to indicate the top of your painting.

6. Draw the same number of squares in your painting rectangle as a larger grid then draw what you see in each corresponding square in the photograph.

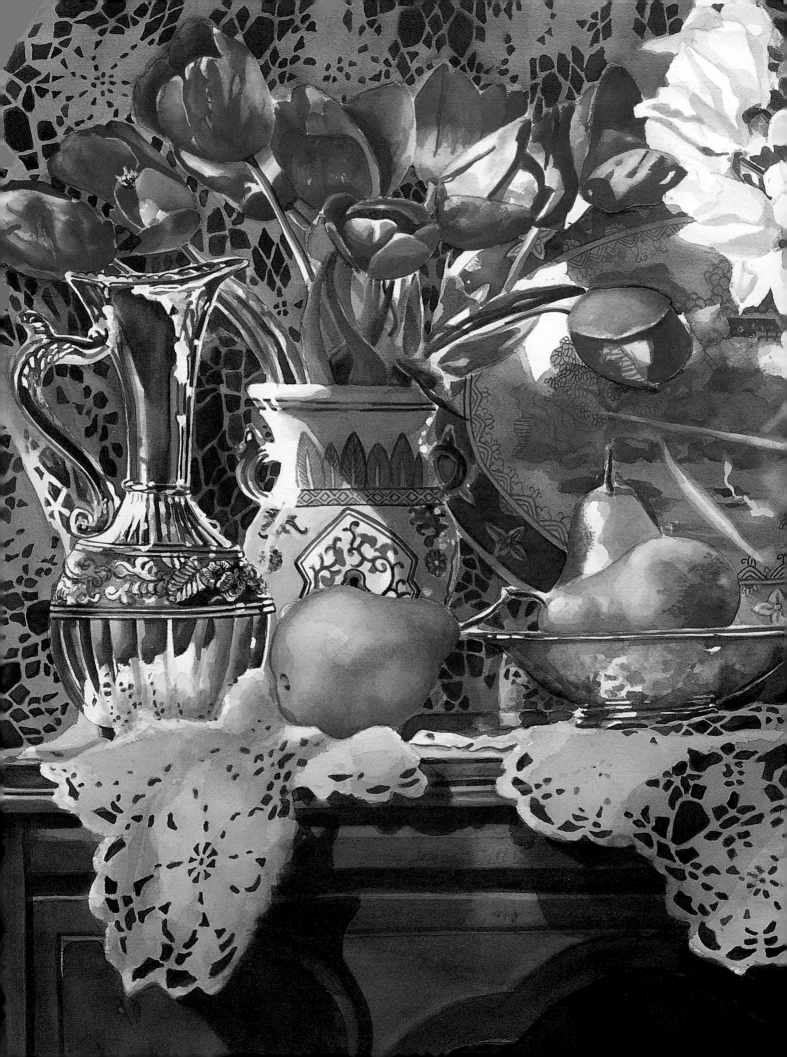

Techniques

Developing consistent techniques and making mistakes along the way are all part of the process of becoming a better artist. I can remember creating painting after painting of muddy colors and dull shadows. I think I got one good painting out of every three that I did. I discovered what I was doing wrong after reading a few North Light books and magazine articles. I wasn't letting the glazes dry in between applications and this was creating mud on the paper. With the new techniques I had learned, my paintings immediately began to liven up.

My techniques don't have to become your techniques. You'll ultimately find what works best for your style of painting. Learning the basics will give you the confidence to paint more freely. The old saying of practice makes perfect stands true when it comes to techniques and skill. The more you paint, the more the knowledge will feel like intuition.

Still Life
29" x 23" (74cm x 58cm)

Washes

Flat washes can be painted over large or small areas and with any size brush. Laying down an even, flat wash can be a challenge if you are new to painting. If you use a large brush, you can cover a large portion of the paper in fewer strokes (less opportunity for streaky washes). If you want a darker wash, use less water in your mixture.

The secret to a successful flat wash is to leave the wash alone once you've laid it down. Touching the paper again or tilting it will cause the paint to become uneven. Keep your paper flat and let the wash dry naturally.

Graduated washes are used to create a subtle and soft gradation in color value from dark to light. It requires a careful control of both your brush and the water-to-paint ratio, adding more water to the mixture as you work your way down the area. Keep your wrist and arm loose during this process and use a slight pressure with the brush, letting the paint do the work of mingling with the water.

The variegated wash is the easiest. It is a loose and watery technique that results in a mottled effect on the paper. Use this when painting backgrounds and variegated surface textures.

Flat Wash

Load your brush with color and with very little pressure, glide your brush across the paper from one side to the other. For the next pass, pull the paint with you from the last stroke you made and continue down the paper, repeating this technique with even, measured strokes.

Graduated Wash

Start at the top of your paper with a fully loaded brush. Pull the paint across horizontally until you're halfway down the selected area. Quickly dip your brush in water, but don't rinse it completely—you only want to dilute the pigment on your brush. Continue moving down the paper, letting the wash lighten as you pull less and less paint with your brush.

Variegated Wash

Create this type of wash by mixing paint with a lot of water and applying it in loose, angular strokes with a round brush. Add the second color immediately after applying the first, creating a wet-in-wet mottled texture.

Drybrushing

Drybrushing is a technique that involves painting in a manner that leaves loose, textural coverage of paint with enough variety of strokes to let the colors underneath show through. The brush holds only a little paint in this technique, hence the name. This technique is the best way to emphasize the textural quality of a subject such as hair, stone, wood, grass or any other weathered, rough surface. You should only drybrush over other dried layers of paint; otherwise, the paint will bleed or create a wet-in-wet wash instead.

Close-Up

You only want a little bit of paint on the brush, so wipe it off on a paper towel right after loading it with paint. Lightly run your brush over the area, letting the bristles of the brush splay out. Any underlying paint must be dry in order for this technique to work properly.

LAYERED DRYBRUSHING

I layered the drybrushing by starting with a light drybrush layer composed of Burnt Sienna and Antwerp Blue mixed with a lot of water. I then let the mixed color evaporate on the palette for a few hours and repeated the process with the new, more concentrated pigment. Once that layer was dry, I added a touch of Alizarin Crimson to the mixture and added the last layer of drybrushing in the darkest darks.

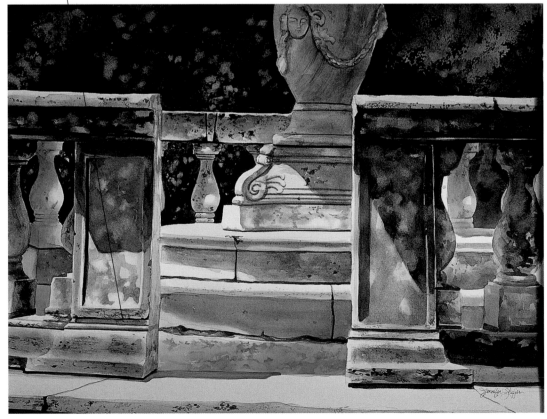

Wet-on-Dry

When an artist paints wet-on-dry, he or she applies paint to a dry surface. The dry paper doesn't allow the stroke to spread, so the edges of the stroke remain crisp and distinctive.

Combining techniques will produce the most three-dimensional results. In this case, you'll paint wet-on-dry over a completed wet-in-wet wash. The final dry strokes of Hooker's Green distinguish the foreground palm fronds from the background.

Wet-on-Dry
You probably already use this stroke but aren't aware it's called wet-on-dry. This technique is good for the final details in a painting, such as the pattern on a piece of china or the foreground grasses in a landscape.

Materials

PAPER
Arches 300-lb. (640gsm)
 cold press

PAINT
Antwerp Blue
Burnt Sienna
Hooker's Green
New Gamboge

BRUSHES
Mop brush
Nos. 6, 8 round

OTHER MATERIALS
Masking fluid
Rubber cement pickup

1 DRAW AND MASK | Transfer your drawing to the watercolor paper and mask out the areas that you want to keep white or light, particularly the areas of intense highlights along the fronds.

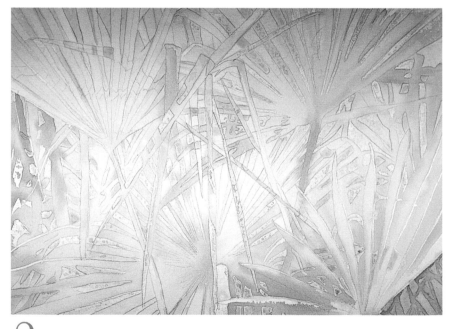

2 START WET | Wet the entire paper. Load your mop brush with New Gamboge and paint the paper. While the wash is still wet, rinse the mop brush and reload it with Antwerp Blue. Apply the Antwerp Blue to the areas of the painting that will be the darkest, letting the two colors mingle. Let everything dry, then repeat the process twice more.

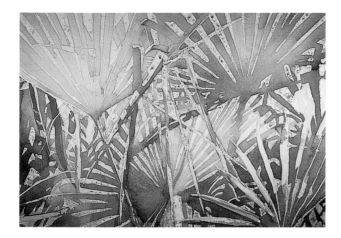

3 BEGIN WET-ON-DRY STROKES | Load your mop brush with Hooker's Green and then paint the left and right background areas. Load your no. 8 round with Hooker's Green, then "draw" the shadows where the single leaves cross each other.

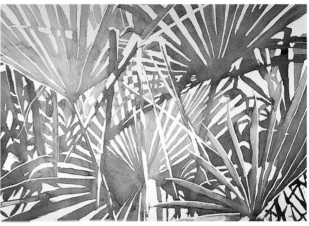

4 REMOVE MASKING FLUID | Using a rubber cement pickup, gently remove the masking fluid from the dry paper.

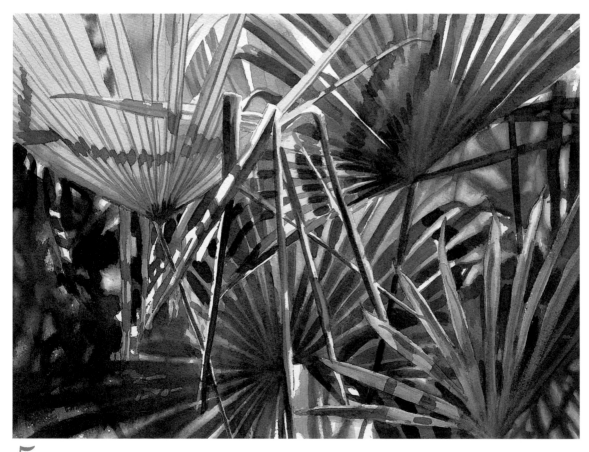

Palm Fronds
13" x 18"
(33cm x 46cm)

5 VARY THE GREENS | Glaze the unmasked areas that you want to come forward with a no. 6 round and New Gamboge. Once the glaze is dry, use your no. 6 round to add Hooker's Green wet-on-dry. Add Burnt Sienna with the no. 6 round to the stem and frond ends, wet-on-dry. For the darker fronds and shadows, use Hooker's Green mixed with Antwerp Blue and a touch of Burnt Sienna. Apply this color wet-on-dry with your no. 6 round to the areas that you want to recede and where fronds cross one another or are in deep shadow.

Wet-in-Wet

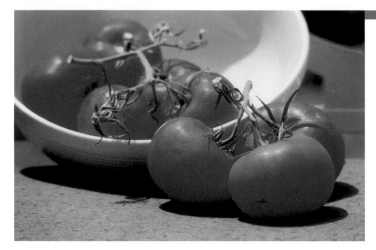

Painting wet-in-wet is not a difficult skill to master. You load your brush with paint and apply it to paper that is already wet (either with water or another paint). The paint spreads on the paper, resulting in soft, diffused edges. This effect is excellent for modeling an object's form—especially in rendering the roundness of fruit or the delicate fold of cloth—but it also works really well as a background. When used in a background, its soft, unfocused quality directs the viewer back to the more prominent foreground.

There's a lot more control in this technique than there might seem. You are not leaving the result completely to chance; you have control over how hard or soft you apply the brush and you can vary the look by using less or more paint. In the examples to the right, I've used a different sized brush to change the result.

To accomplish the plump, glossy smoothness of these vine-ripened tomatoes, you'll need to paint consecutive wet-in-wet washes of juicy yellows and reds.

Materials

PAPER
300-lb. (640gsm) cold press

PAINT
Alizarin Crimson
Antwerp Blue
Hooker's Green
New Gamboge
Permanent Red
Quinacridone Red
Winsor Violet

BRUSHES
Mop brush
Nos. 6, 8 round

OTHER MATERIALS
Masking fluid
Paper towels
Rubber cement pickup

Wet-in-Wet
This wet-in-wet wash was made by pre-wetting the paper, dipping a no. 8 round in paint, blotting it, and then lightly applying paint to the wet paper, mostly using the tip of the brush.

Get in Control
This is the same wet-in-wet technique, but using a no. 6 round. The smaller brush allows more control if you're working in a tight area.

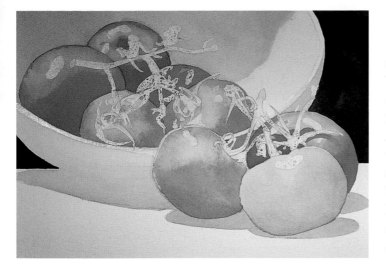

1 PAINT THE FIRST LAYERS | Select a tomato and wet it completely with clean water. While it's still wet, apply New Gamboge with your mop brush. You'll have more control over the next wash if you wait about thirty seconds for this layer to sink in. Load your no. 8 round with a mixture of Permanent Red and Alizarin Crimson. Add this to the darker parts of the tomato, starting where the form shadow begins. Let the spreading paint do the work for you. If too much paint bleeds into an area that you want to keep light, blot it. Repeat this process with the other tomatoes, but move around the painting so the tomatoes don't bleed into each other.

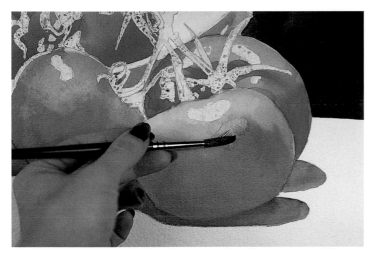

2 MAKE THE COLORS JUICY | Using your no. 8 round, paint the shadow area under the tomatoes and on the bottom of the bowl with Winsor Violet. Dip your no. 6 round in some Quinacridone Red and float it into the still wet Winsor Violet shadow. Once tho shadows are dry, wet the tomato again. With your no. 8 round, paint the darkest point Quinacridone Red, letting the color bleed outward. Complete the rest of the tomatoes this way. If you feel the red isn't juicy enough, you can let these wet-in-wet washes dry then repeat the process with another layer of Quinacridone Red.

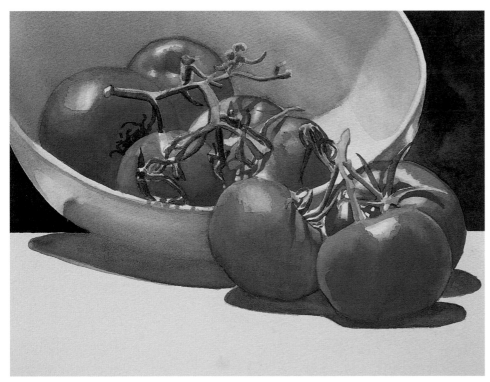

3 ADD DETAIL WITH WET-ON-DRY | Remove the masking fluid with a rubber cement pickup and begin the wet-on-dry detail. Use your no. 6 round on the stems, starting with New Gamboge, then moving on to Antwerp Blue. Follow with Hooker's Green. To create the cast shadows on the tomatoes, use a deeper value of Quinacridone Red mixed with Alizarin Crimson.

Maties
11" x 17" (28cm x 43cm)

Glazing

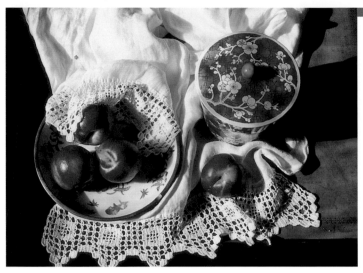

Glazing is the process of applying consecutive layers or washes one over another. The result of glazing is a luminous glow. You can apply the paint in thin or thick layers, as long as you allow the layers to dry completely in between glazes. This layering creates a more realistic texture and depth on items compared to the result when only one application of paint is applied. Glazing is also a good way to layer different colors to create your final desired color. To get the spring green of leaves, for example, you would apply Cobalt Blue, let that dry, then add New Gamboge as a final coat and possibly add details with some Sap Green or Hooker's Green.

Shadows are what give paintings instant life, but shadows cannot be achieved with one dark wash of color. It takes many layers of color, sometimes as many as twenty, to get the correct value balance.

Materials

PAPER
Arches 300-lb. (640 gsm)
 cold press

PAINT
Alizarin Crimson
Antwerp Blue
Burnt Sienna
Cobalt Blue
Quinacridone Gold
Winsor Violet

BRUSHES
Mop brush
No. 8 round

OTHER MATERIALS
Masking fluid
Paper towels
Rubber cement pickup
Tracing paper

One Glaze of Color
Even with a graded wash, it is difficult to get much depth with only one application of paint.

Get in Control
This color block was done with three glazes of color, with the paint area getting smaller with each glaze. I call this "retreating into the darks." Notice how the color deepens in the lower right. The sequence was Quinacridone Gold, Burnt Sienna, then Alizarin Crimson.

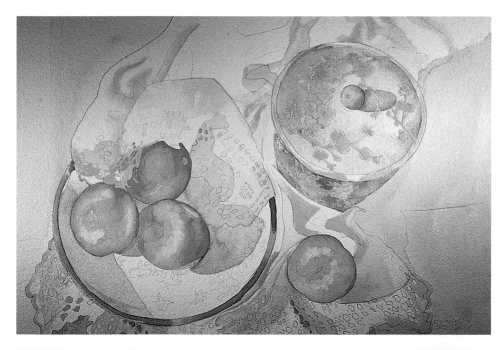

1 PAINT THE CAST SHADOWS | First, mask any areas that you want to keep white or light, such as the highlights or the flowers on the vase. Using your no. 8 round, lay a light wash of Cobalt Blue inside the fruit bowl and on the cloth to indicate the cast shadows. Let this wash set in for about thirty seconds, then float some Alizarin Crimson wet-in-wet to imitate the reflection of the nectarines. Apply a wash of Quinacridone Gold to the tabletop. Then, using your mop brush, lay a wash of Cobalt Blue to the right of the canister.

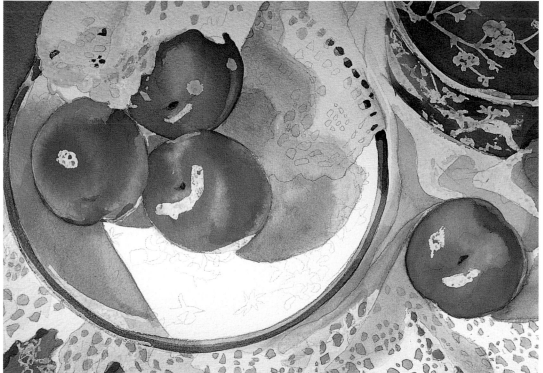

2 GLAZE ADDITIONAL COLORS | For this step, use your no. 8 round. Make sure the cast shadows are all sufficiently dry, then glaze them with a wash of Winsor Violet. Once this is dry, glaze the shadows with a layer of Alizarin Crimson.

Cobalt Blue

Cobalt Blue is the one color that will never get darker than the first application, no matter how many layers of it you use. While it is the best color to use when starting a painting and in light washes, you must move to a different blue for deep shadows.

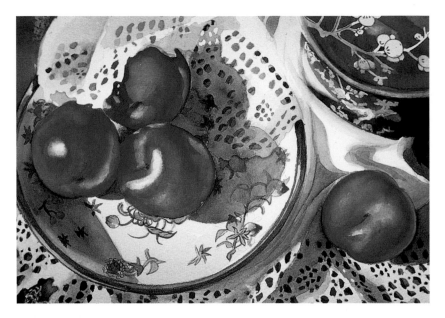

3 DEEPEN THE SHADOWS | After removing the masking fluid from the rest of the painting, glaze the nectarine shadows with yet another wash; this one of Antwerp Blue. When that wash is dry, glaze the area with Winsor Violet. Add a wash of Burnt Sienna to the table shadow using a no. 8 round. When the cast shadows in the bowl are dry, paint the details inside the fruit bowl using a wet-on-dry brushstroke.

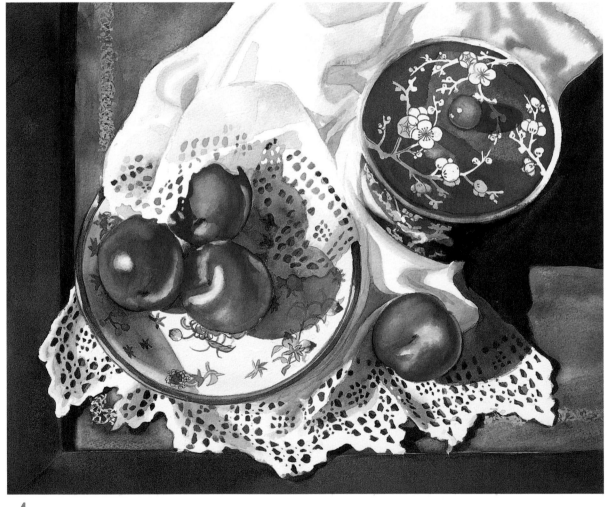

Nectarines
18" x 15"
(46cm x 38cm)

4 ASSESS THE VALUE CONTRAST | To determine if your shadows are dark enough, cover the painting with a piece of tracing paper. This will minimize the distraction of the details and you will be able to see the darks and lights more easily. I decided there wasn't quite enough value contrast (too many lights), so I glazed several more layers of Burnt Sienna and Winsor Violet on the table's shadow and more layers of Antwerp Blue on the cloth's shadow. How far you go is up to you, but the more you exaggerate dark from light, the more pleasing the final result.

Stippling

Stippling is an excellent technique for adding texture in the last stages of a painting. The process is simple; use a color with a dark value and apply paint in random patterns of quick dots with a small round brush. This technique is ideal for rendering an item with rough texture like a wool rug or an animal with short fur.

Dots of Color

In general, a small brush works best for stippling. In this case, I created the small points of color with a no. 4 round using quick, drybrush strokes.

STIPPLING THE WOOL RUG

You can create the rough textural pile of a wool rug by stippling small pointed dots of the deep shades of rug color. Here, it was achieved with Alizarin Crimson over the red wash, Hooker's Green over the pale green wash and a diluted Winsor Violet in the white areas.

This technique can be easily overdone, so be careful not to go overboard with too many dots. You want to suggest the rug's texture and depth and too much stippling will cause the rug to look polka-dotted or dirty. The more light that is cast on an object, the less detail you will see. Stipple in the shaded or darker areas of the rug and leave any areas that are in the lighter areas untouched.

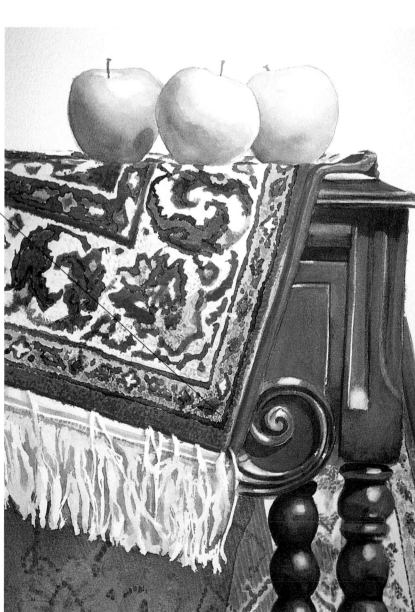

Wool Rug
16" x 12"
(41cm x 30cm)

Underpainting

Underpainting is very similar to glazing. Underpainting involves painting a basecoat first, then ending with the local color on top of that basecoat. In watercolor, you use underpainting to do the heavy lifting—form the basic shape—and then use the subsequent layers to give it a three-dimensional feel. The underpainted color usually should be a close relative of the final color to give it more depth.

This example shows how underpainting can help to model the muscle mass of this young horse's body. The underpainting technique can be used for other animals as well. Animals with a lot of hair should be finished with wet-on-dry strokes to imitate fur.

Materials

PAPER
300-lb. (640gsm) cold press

PAINT
Antwerp Blue
Burnt Sienna
Quinacridone Gold
Winsor Violet

BRUSHES
Nos. 6, 8 round
No. 2 scrubber brush

OTHER MATERIALS
Masking fluid
Paper towels
Rubber cement pickup

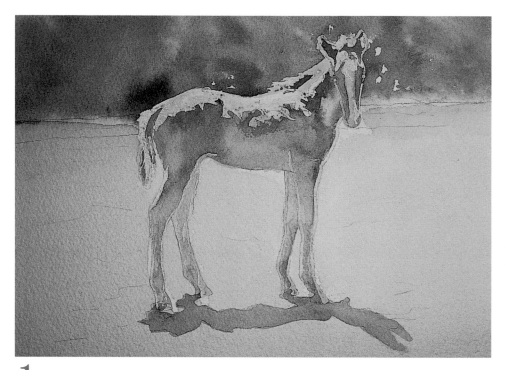

1 **CREATE A PURPLE HORSE** | Mask out any areas of the horse that will remain white. Lay a Winsor Violet wash over the horse's form using your no. 6 round. When this is dry, lay down a second, darker concentration of Winsor Violet in the muscles. While this is still damp, use your no. 6 round to float Antwerp Blue into the horse's ear, neck and back. Once dry, add some Quinacridone Gold on the horse's belly with your no. 8 round.

Breaking It Down
I've broken down the underpainting and its subsequent layers below. You can see how the strange beginning of Winsor Violet results in a wonderful color for the horse.

 + = + =

VIOLET QUINACRIDONE GOLD (NEW COLOR) BURNT SIENNA (NEW COLOR)

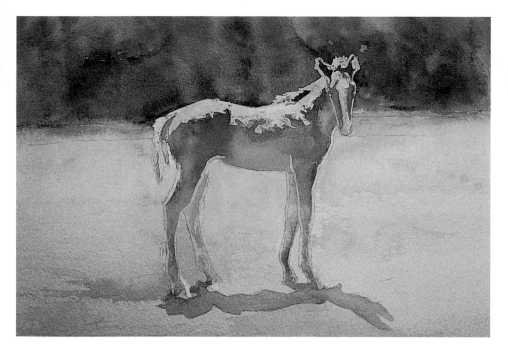

2 **ADD THE LOCAL COLOR** | Use your no. 8 round to add Burnt Sienna to the entire horse. A second coat may be necessary.

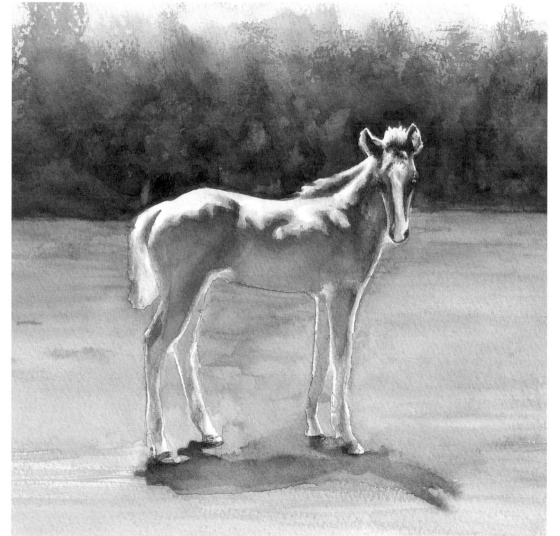

Jake's Foal
9" x 9"
(23cm x 23cm)

3 **EVALUATE AND ADJUST** | Remove the masking fluid using your rubber cement pickup. Lightly scrub and blot the areas that need to look more sculptured and soft with a no. 2 scrubber. At this point, reevaluate the darks, midtones and light areas. Add or subtract paint as needed.

Masking

Masking fluid is liquid latex rubber. You apply it directly to the water-color paper, using it to cover light or white areas or delicate details. Masking fluid allows you to work freely; you can apply washes without having to worry about painting around delicate details.

Masking fluid can be applied with an old brush, an embroidery needle, or masking tape wrapped around a pencil point. Never apply it to wet paper and don't leave the fluid on the paper for extended periods of time.

Masking fluid does leave behind a harsh edge, so in most cases you will want to smooth out the edges with a wet scrubber brush and blot gently with a paper towel.

Materials

PAPER
Arches 300-lb. (640 gsm)
 cold press

PAINT
Antwerp Blue
Burnt Sienna
Hooker's Green
New Gamboge
Quinacridone Gold
Winsor Violet

BRUSHES
Mop brush
Nos. 6, 8 round

OTHER MATERIALS
Masking fluid
Paper towels
Rubber cement pickup

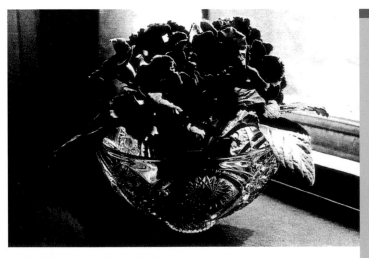

DETERMINE WHAT TO SAVE
The use of masking fluid requires some planning. If you are unsure about what parts of your initial drawing should be masked out, make a black-and-white copy of your reference photo. This will show you where the lightest areas are that you will need to save.

Fluid on Paper
This is what the dried masking fluid looks like on paper. The pale yellow color helps you to locate masked areas while painting. Once the masking fluid is dry, apply the paint over it.

Once the paint is dry, remove the masking fluid by gently rubbing the area with a rubber cement pickup. Everything that was under the fluid should have remained white.

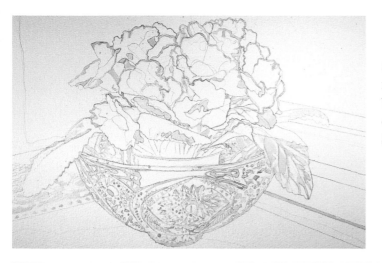

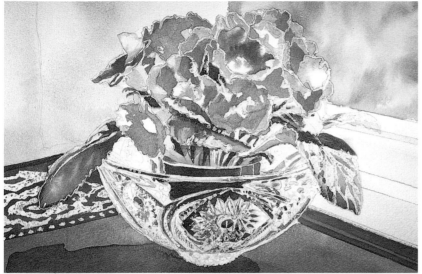

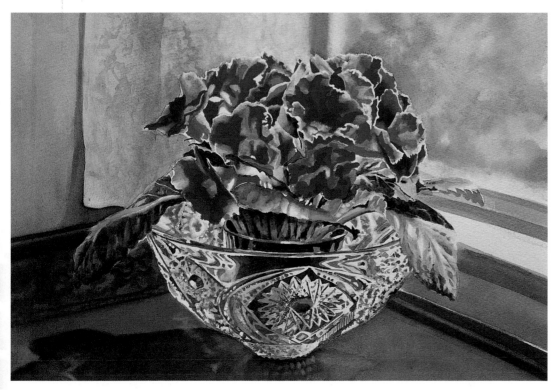

1 DRAW WITH MASKING FLUID | There'll be more masking fluid than paint once you are done with the bowl. Look carefully at your reference photo and the photocopy to decide which areas to mask. It's always better to mask out more than you think you'll need because you can always cover the white. Once the masking fluid is dry, use wet-on-dry strokes of Antwerp Blue, Winsor Violet and Burnt Sienna in the open areas.

2 REMOVE THE MASKING FLUID | Use a rubber cement pickup to remove the masking fluid. Use your no. 8 round to paint all the colors you see reflected in the cut glass. The table reflects Burnt Sienna, and the leaves and the pot reflect a deep blue-green. The light reflected from the window is Winsor Violet. The areas that can be seen inside the bowl are less detailed because they are further away from the viewer.

3 FINISHING TOUCHES | Use your mop brush to add a light Antwerp Blue vertically across the middle front of the bowl. This gives the bowl the illusion of roundness. To deepen and define the cut starburst, you want to use barely diluted paint and your no. 6 round.

Gloxinia
12" x 16" (30cm x 41cm)

Scrubbing and Lifting

Scrubbing and lifting are extremely useful skills when painting with watercolor. Because you remove paint, these are referred to as subtractive techniques. Scrubbing and lifting are wonderful for creating the soft textures of flowers, as in this demonstration.

Most mistakes in watercolor can be fixed with a scrubbing or lifting technique. The process works better on 300-lb. (640gsm) paper, but the 140-lb. (300gsm) paper can handle the techniques without heavy surface marring.

Materials

PAPER

300-lb. (640gsm) cold press

PAINT

Antwerp Blue

Burnt Sienna

Hooker's Green

New Gamboge

Opera

BRUSHES

Nos. 6, 8 round

Nos. 2, 6 scrubber brush

OTHER MATERIALS

Masking fluid

Paper towels

Rubber cement pickup

Scrubbing

The masking fluid has been removed and the area is ready for scrubbing. Next, the edges are gently scrubbed with a wet scrubber brush and blotted with a paper towel.

Lifting

In an area of layered paint, use a wet scrubber brush and a swift swirling motion to remove paint, then blot with a paper towel.

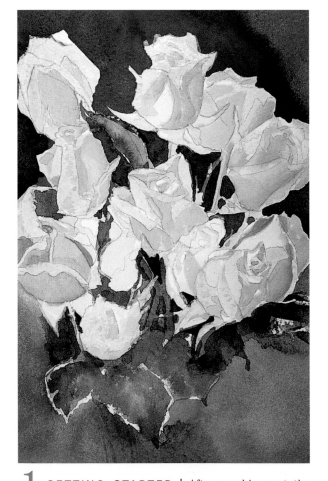

1 **GETTING STARTED** | After masking out the highlights on the flowers and stems, apply Opera to the pink roses and New Gamboge to the yellow roses, leaves and stems.

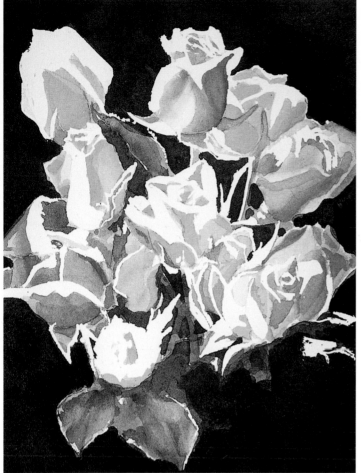

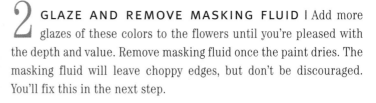

2 **GLAZE AND REMOVE MASKING FLUID** | Add more glazes of these colors to the flowers until you're pleased with the depth and value. Remove masking fluid once the paint dries. The masking fluid will leave choppy edges, but don't be discouraged. You'll fix this in the next step.

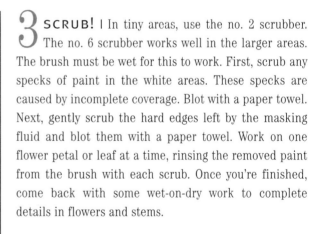

3 **SCRUB!** | In tiny areas, use the no. 2 scrubber. The no. 6 scrubber works well in the larger areas. The brush must be wet for this to work. First, scrub any specks of paint in the white areas. These specks are caused by incomplete coverage. Blot with a paper towel. Next, gently scrub the hard edges left by the masking fluid and blot them with a paper towel. Work on one flower petal or leaf at a time, rinsing the removed paint from the brush with each scrub. Once you're finished, come back with some wet-on-dry work to complete details in flowers and stems.

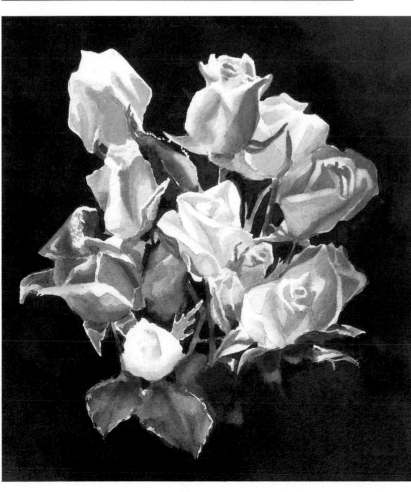

Roses
8" x 10"
(20cm x 25cm)

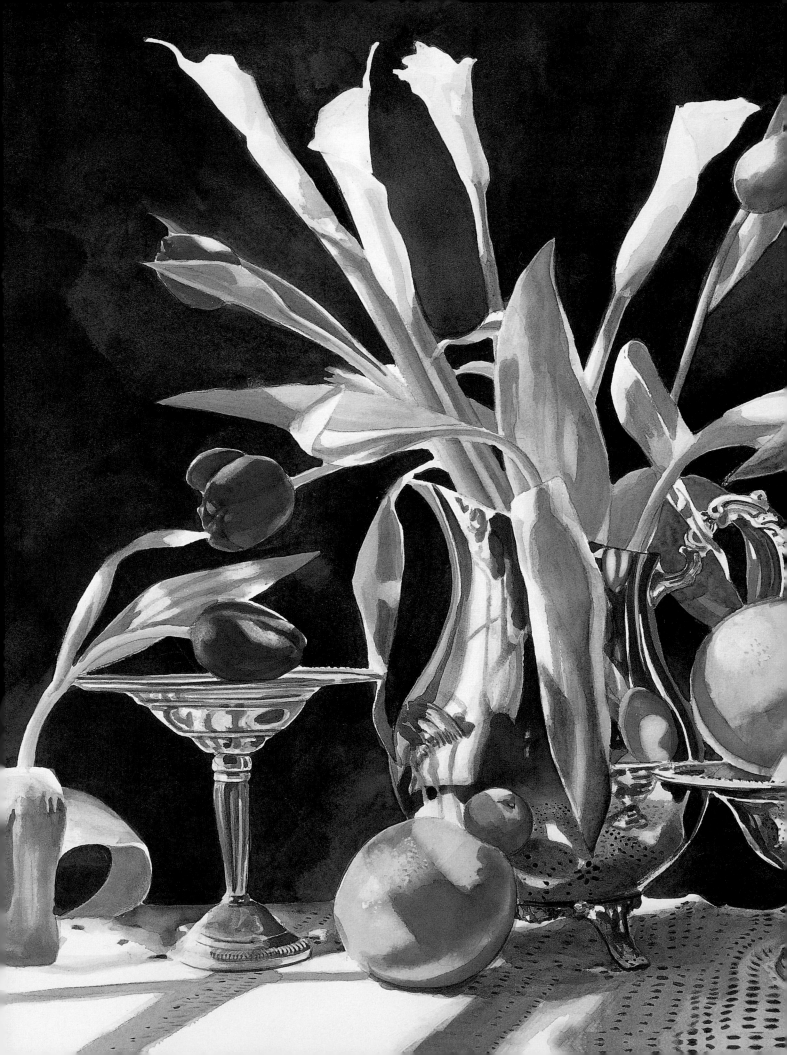

Capturing Light

Strong lighting is the final element that pulls a good composition together and helps create the mood in a painting. Natural light gives the best results, whether it is the crispness of early morning light or the orangy-blue glow and long purple shadows of the late afternoon.

The best way to capture light in a painting is to exaggerate light and shadow. Some items are bathed in so much light on the highlight side that you need only let the white of the paper represent them. Some shadows will be so dark that the edges may seem to be "lost" or have no edge at all. To make sure that my eyes don't fool me, I often make a black-and-white photocopy of the reference photo to ensure I understand the light and dark values correctly. This chapter will teach you to train your eyes to see the light and shadow and how to translate what you see into watercolor.

Callas, Tulips and Oranges
22" x 30" (56cm x 76cm)

Working With Natural Light

Natural light is the best to work with because it allows for sharp contrasts in light and dark, which is essential in watercolor. Studio lighting is too even and doesn't give objects or people that extra spark. I see sunlight as part of the composition.

In the winter, I use the window in my kitchen to set up still life compositions and photograph them. I get great angled sunlight and marvelous cast shadows from the small windowpanes. In spring and summer, I move photo shoots outside into the intense sunlight. I shoot my photos in the early morning and late afternoon to capture the best angled light. Around noon, I might take a few shots with top lighting; these sometimes help me interpret details in the composition.

Side Light

Angled light or side light occurs when your light source is at a 45-degree angle to your subject. Side light creates extended shadows on one side of the subject and bright highlights on the other. It can also establish a strong sense of three-dimensionality. If you're working with a sidelit subject, try pushing the extremes. Yes, your brain is telling you the leaf is green, but that doesn't mean paint some light green, paint some dark green, and then you're done. The highlighted area may be so intense that there's no needs to paint it at all; it's white. Maybe the light is hitting the leaf from behind; you might decide to use yellow to depict that translucency. The shadowed side of the leaf might be blue. The cast shadow may be a mixture of violet and green.

FINDING NATURAL LIGHT
For still life paintings, I use the natural light coming through my south-facing kitchen window. I can do this only during winter months when there are no leaves on the large sycamore tree just outside the window.

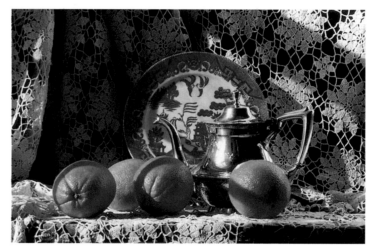

SIDE LIGHT ADDS DRAMA
This is a great example of angled light adding drama, even through the window. The highlights are strong and the window panes create great cast shadows, suggesting the idea of a window without showing one.

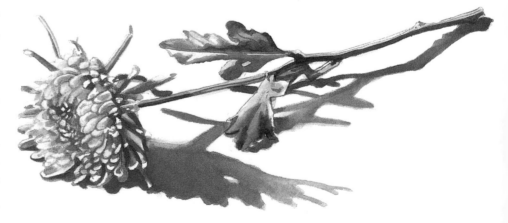

PUSH THE EXTREMES
Side light allows you to take some risks with exaggerated values and shadow patterns. In order to depict this light, I kept areas of the purple flower pure white where the light hit strongest. I painted the leaves and stem in yellows, greens and blues to capture the tone of the light.

Reflections

When an object reflects light and casts shadows, our brains assume it must have volume. Using shadow and reflections is the surest way to give the objects in your painting a three-dimensional feel. Using highly reflective objects, like glass or silver, is especially effective. These items absorb the colors around them and distort the reflected images to create an abstract painting within a realistic one.

One of my favorite things to paint is the reflections in silver because it's such a challenge. It's not quite as hard as it looks as long as you concentrate on small areas at a time. Think of the reflections as abstract shapes of color. Use the drybrush technique after the initial glaze of local color. Step far away from the painting often and you'll be surprised at how quickly it'll begin to look like a reflective surface.

I handle water and glass reflections the same way, by painting abstract color shapes. When items are immersed in water, however, things change. The preliminary drawing needs to be handled carefully. Light bends underwater, which is called refraction, and the image is magnified. Through careful observation of how things change underwater, you can achieve this effect realistically in watercolor.

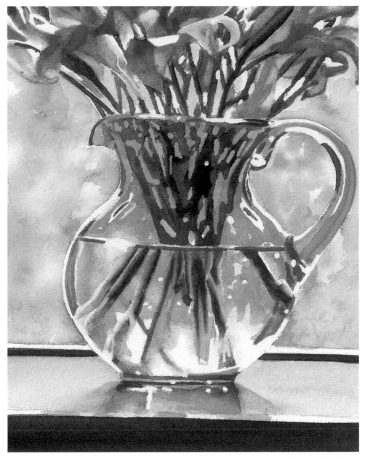

OBSERVE REFRACTION

When stems are submerged in water, the light is bent and the image is magnified. The stem going into the water doesn't match up with it's own image under the water.

Tiger Lilies
6" x 5"
(15cm x 13cm)

USE MASKING FLUID FOR AREAS IN BETWEEN STEMS AND FILL WITH VASE COLOR AT THE VERY END OF THE PAINTING

STEM ENDS GET THIN WHEN THEY REACH THE BOTTOM OF THE VASE WHERE STRONG LIGHT IS OBSCURING THEIR FORM

STEMS ARE MAGNIFIED UNDER THE WATER LINE

USE A DARK VALUE WHEREVER GLASS MEETS ANOTHER OBJECT

Artist's Eyes

Artists see things a little differently after they've been painting for a while. On any normal day, a forest is a forest. On a painting day, the trunks of the trees are purple and there's a yellow glow between all of the trees!

Backlighting

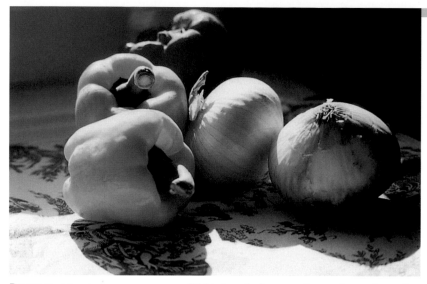

BACKLIT OBJECTS HAVE A HALO of light. Any shadows are thrown forward, creating a theatrical and dramatic mood. To achieve this effect, set up in front of a window or on a small table outside, making sure the sun is behind the objects. Again, the early morning and late afternoon are the best times of day for this. Use items that are translucent, such as glass, leaves, flowers and china; the light will pass through them from behind and make them glow. Portraits also work well with backlighting. It gives the subject an ethereal feel.

Materials

PAPER
Arches 300-lb. (640gsm) cold press

PAINT
Alizarin Crimson
Antwerp Blue
Burnt Sienna
Cobalt Blue
Hooker's Green
New Gamboge
Quinacridone Gold
Vermilion Deep
Winsor Violet

BRUSHES
Mop brushes (3)
No. 6 round
Scrubber brush

OTHER MATERIALS
Masking fluid
Paper towels
Rubber cement pickup

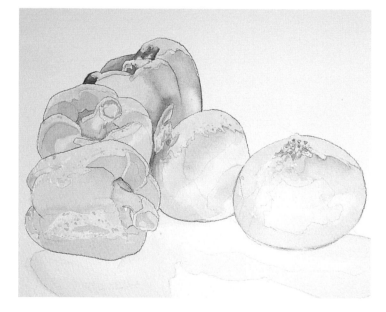

1 **MASK THE HALO** | First, apply masking fluid to any of the areas you wish to protect, especially the highlights on top of the vegetables. Using your no. 6 round, paint a wash of Antwerp Blue on the pepper stems. In the darkest area of the red pepper, paint a wash of Winsor Violet. Once this is dry, add some Vermilion Deep in the light areas. Use two coats of New Gamboge for the yellow peppers, letting them dry completely between washes. For the onions, first paint a wash of Burnt Sienna, then follow with a light, wet-in-wet wash of Vermilion Deep in the areas nearest the red pepper. Once the vegetables are dry, apply a wash of Cobalt Blue to the shadow shape.

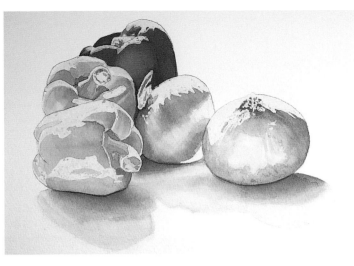

2 DEEPEN AND DARKEN | Mix some Quinacridone Gold and Alizarin Crimson. Drybrush this color onto the darker areas of the yellow peppers. Paint the pepper stems with wash of New Gamboge. Add a wash of Alizarin Crimson and some Vermilion Deep to the red pepper. To the darkest parts of the pepper stems, add Antwerp Blue and then Hooker's Green. Apply a wash of Quinacridone Gold to the parts of the shadow closest to the yellow pepper. Deepen the onions' shadow with Burnt Sienna. All of Step 2 can be repeated once the washes are dry, but paint smaller and smaller areas with each pass.

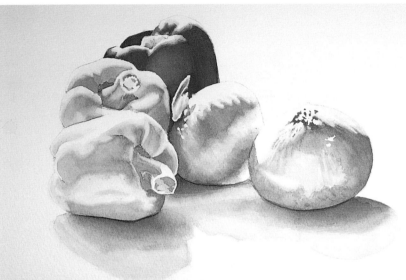

3 SCULPT WITH THE DARKS | Remove the masking fluid. Use a wet scrubber brush to soften any hard edges, blotting quickly with a paper towel. In the darkest area of the vegetables, add a few more glazes of the colors used in the previous steps. Once the masking fluid is removed, you should have a clearer idea of the overall values of the painting. Wet the middle section of the onion on the left with clear water. Load your no. 6 round with Burnt Sienna to drop in the color. This helps to create a modeled form. Do the same with the right side of the other onion.

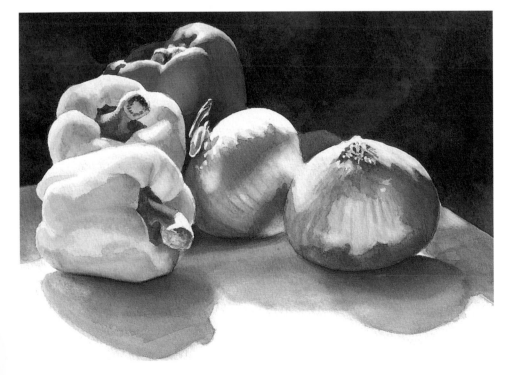

4 ADD THE FINISHING TOUCHES | Apply a thick wash of three different colors to the background: Alizarin Crimson, Burnt Sienna and Hooker's Green. Use a different mop brush for each color. Drag some Alizarin Crimson across the background. Switch to your Hooker's Green brush. Meet the Alizarin Crimson wash with Hooker's Green and then drag. Follow this with the Burnt Sienna. Repeat this step, alternating these three colors until the background is covered. Let everything dry and then repeat this process twice.

Peppers and Onions
11" x 9" (28cm x 23cm)

The Play of Shadow and Light

Shadow and light are necessary for defining large masses, adding contrast and connecting items to their surrounding space. Shadows in particular will keep items from looking like they're floating on the paper.

A **cast shadow** is cast by an object onto another surface. The stronger the light source, the harder edged the cast shadow.

A **form shadow** can be found on the side of the object facing away from the light. This side of the object is illuminated only by indirect light, so it is comparatively darker. On rounded objects, the form shadow will generally be darker in the center and diffuse as it moves toward the light.

Within cast and form shadows you will often find **reflected light**, or light that has bounced into the shadow indirectly. This will appear as a soft glow of reflected color within the shadow, usually toward the base of the shadow.

Another important form of light involved is the **highlight**. This is where direct light hits the object. Highlights are also reflected light, but its intensity bleaches out any detail in that area.

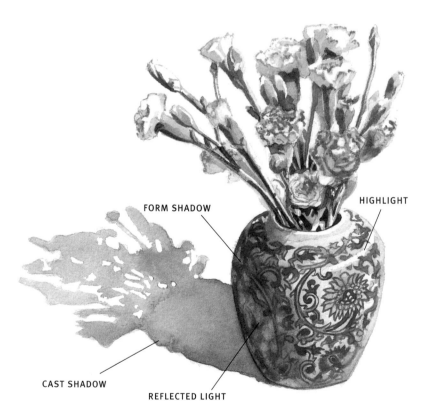

FORM SHADOW

HIGHLIGHT

CAST SHADOW

REFLECTED LIGHT

ACCOMPLISHING SHADOWS
The cast shadow here is a hard-edged wash of Cobalt Blue that turns Violet closer to the vase. In the areas of deepest shadow, I dropped in a touch of Quinacridone Gold to imitate reflected light. The soft shadows on the vase itself create the form shadow in light, successive layers of Antwerp Blue and Alizarin Crimson. The details on the vase were added last, including a thin stripe of Burnt Sienna at the bottom of the vase to "seat" it and give it weight.

Hard and Soft Shadows

A hard shadow will always be a cast shadow. The edges are clearly defined and crisp where the shadow meets the sunlight. Hard shadows show the relationship between the object and the space around it and tell us about the object's translucency and the time of day. They are usually painted on a dry surface to keep the edges crisp.

Soft shadows model the form, giving an object its three-dimensionality. Soft shadows can be cast shadows, too, but they are generally less distinctly edged. Soft shadows are usually created by painting wet-in-wet, but they can also be created by scrubbing an area after you've removed masking fluid.

What Color Is a Shadow?

Some artists will avoid creating deep shadows because they are unsure of which colors to use. A shadow is rarely a straightforward gray or black, and using either of these from the tube will cause dull shadows and backgrounds.

A shadow is usually a reflection and a deeper value of the local color of an object. A tomato's local color is red, so its shadow will cast a deeper value of that red.

It's better to create shadows in stages rather than all at once. Add consecutive glazes as you work on the rest of the painting to retain color harmony. You still have the option to continue building color with even more layers even after you've finished details in the painting. I've been known to come back to a painting long after it's "finished" to add more Antwerp Blue or Winsor Violet in the shadows, just to push the darks more.

Use Different Patterns

You can create patterns with natural light by filtering it through things like lace, windowpanes, gates or even straw hats. This adds an interesting dimension to your work by making shadow patterns that pull the viewer to your focal point or help connect all your items together.

SHADOW PLAY

The light source here is off to the left, as you can see from the bright highlights on the left side of the pears. The highlight on the left side of the pot is bright, bleaching out the detail that is easier to see within the form shadow on the right side of the pot. The leftmost pear causes a cast shadow just to the right of its base. The right-most pear, though, bears a cast shadow from the leaf above.

All these lights and shadows work together in the painting, creating different values and reactions in the viewer. The warm, bright light and darker, quiet shadows evoke a feeling of peace.

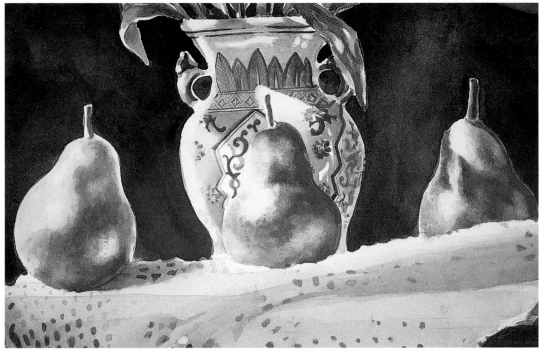

Blue and Yellow
18" x 24" (46cm x 61cm)

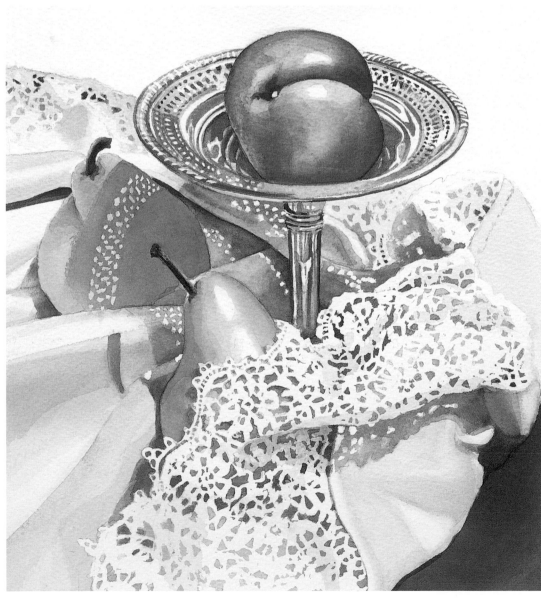

CREATE PATTERNS OF LIGHT

Light pours through the holes in the fretwork on the footed silver dish and seems to stencil the shadows with patterns of light. Arrange your objects until you get the most overlap of sunlight, shadow and pattern. It is important to give the viewer something interesting to look at, even in the shadows.

Light Dance
10" x 9" (25cm x 23cm)

57

Value Contrast

Putting the darkest darks next to the highlights in a painting adds definition and sharpness. The viewer will quickly focus on areas of high value contrast and is more likely to respond to a painting with a good representation of lights and darks. A good way to include lots of value contrast is to work in dark shadows and strong highlights.

To determine whether you've used value contrast properly, make a photocopy of your painting. Another trick to test for appropriate value contrast is to place a piece of tracing paper over your painting.

If the work looks crisp and defined through the diffused quality of the tracing paper, you have succeeded. I use this trick often to show where I need to add more dark values to adjust the contrast and to push the value extremes.

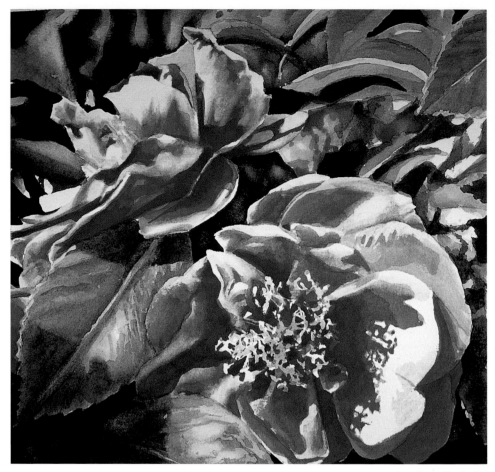

PUSH THE LIMITS
The value contrast in this painting is high because of the use of complementary colors, fewer midtones and the strategic placement of the brightest highlights next to the darkest darks.

Study of Pinks
13 1/2" x 12"
(34cm x 30cm)

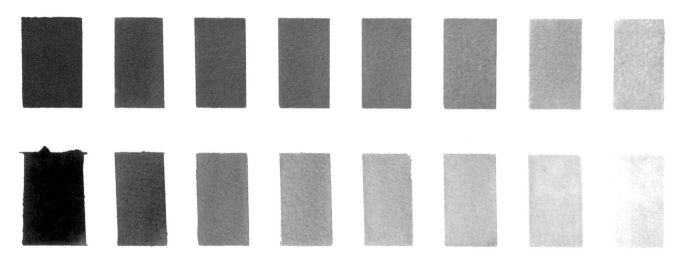

VALUE SCALES
These two strips of color are the basic value scale for the painting above. Normally, a value scale would have a few more midtones, but I like to have fewer steps between the lights and darks. Organize the values in your composition so the lightest value of one can be positioned next to the darkest value of another.

Color Theory

Colors that are in the blue and green range are called cool colors. Reds and yellows are called warm colors. Colors from these categories have different effects in a painting. For example, warm colors appear to come forward, but cool colors give the illusion of receding into space.

Colors will react with each other by either contrasting or harmonizing. Harmonizing colors (also called analogous colors) are colors from the same group (i.e., all warm colors) or hue (i.e., all variations of blue). Colors contrast usually when they are complementary. Complementary colors are opposite from each other on the color wheel and are intensified when put next to each other.

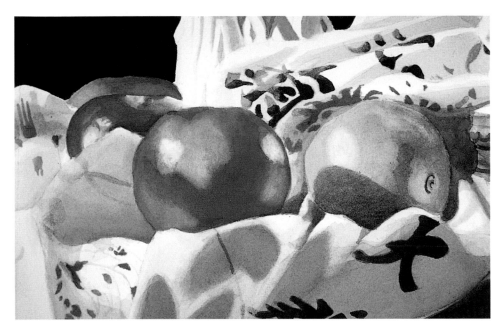

WARM VS. COOL
For the most part, this painting relies on harmonizing colors from the warm group, so the cool green of the lime really jumps out at the viewer.

Tangerines and Limes
11" x 17" (28cm x 36cm)

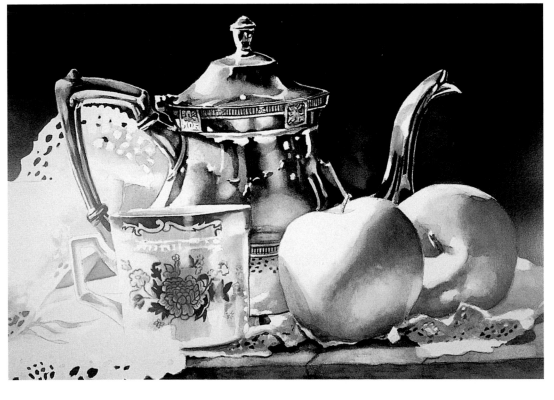

HARMONIZING COLORS
The closely related colors of blue and blue-green in this painting have less contrast and energy, but the common denominator of blue pulls the painting together harmoniously.

Apple Tea
11" x 14" (28cm x 36cm)

Neutral Gray

Knowing how to mix a neutral gray will come in handy for painting items like glass, silver and things that would normally be black, like an animal's fur. When I first started painting I would use Payne's Gray and I never could get it dark enough. It lightened after application, and the darks I did come up with were just too dead-looking and dull.

I came up with this mixture for a neutral gray after much experimentation. The basic mixture consists of Antwerp Blue, Burnt Sienna, Alizarin Crimson and Hooker's Green. This gives you a rich black that can be diluted for a variety of different grays. Once you start using this neutral gray in your paintings, you will never use gray or black from a tube again!

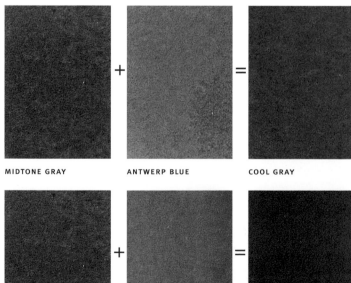

THE COMPONENTS OF NEUTRAL GRAY
A mixture of Antwerp Blue, Burnt Sienna, Alizarin Crimson and Hooker's Green will create a versatile gray that can be customized by adding more or less water, Alizarin Crimson or Antwerp Blue.

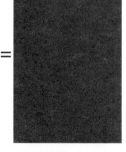

MIDTONE GRAY + ANTWERP BLUE = COOL GRAY

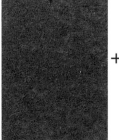

MIDTONE GRAY + ALIZARIN CRIMSON = WARM GRAY

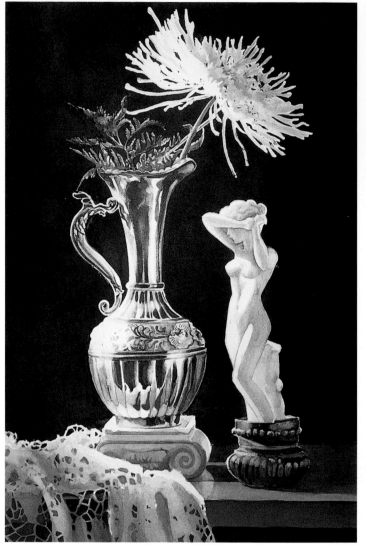

GRAY MATTER
The silver in this vase was achieved by using the three different values of the neutral gray. I painted the details last, using wet-on-dry strokes with the darkest mixture of gray. At one point, there was too much water in the mixture, but instead of adding more color, I left my paint palette exposed to the air for a few hours until some of the water evaporated out of it. This made the thicker, darker gray that I needed.

Chrysanthemum Grace
14" x 20"
(36cm x 51cm)

COOL GRAY AND WARM GRAY
For a cool gray, add Antwerp Blue to the existing midtone gray. For a warm gray, add Alizarin Crimson. Cool gray is the color that I most often use for silver. The warm gray works for some stone and fur.

Bring Light Into Your Painting

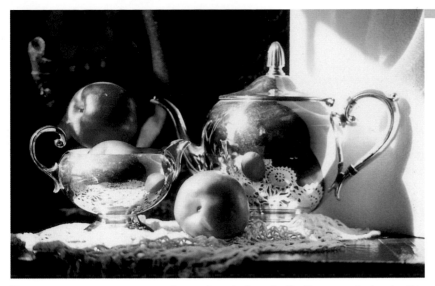

THE EXTREMES OF VALUE and a good rendering of reflections are what make this painting so pleasing to look at.

All the subjects in this painting emphasize the rounded form. I chose the reflective silver pieces to increase the number of round forms in the painting. I also chose the lace for its pattern of repeating circles, but the light value of it makes the reflection of the nectarine really stand out. The white lace also served as a "light bounce." The sunlight bounces off the white lace and onto the other objects in the still life.

I chose a strong sidelight for the painting in order to emphasize the value contrast on all the round objects. Sidelighting contributed the extreme white highlights on one side and the rich, deep shadows on the other. This kind of lighting on round objects gives the most believability in terms of the form.

Materials

PAPER
Arches 140-lb. (300gsm) cold press

PAINT
Alizarin Crimson
Antwerp Blue
Burnt Sienna
Cobalt Blue
New Gamboge
Quinacridone Gold
Vermilion
Winsor Violet

BRUSHES
Mop brush
Nos. 6, 8 round
Scrubber brush

OTHER MATERIALS
Masking fluid
Paper towels
Rubber cement pickup

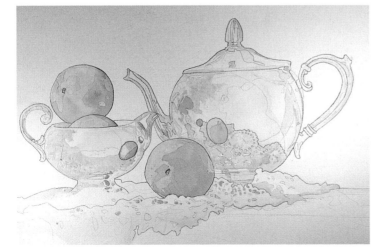

1 PROTECT THE LIGHTS AND APPLY THE FIRST WASHES I Since the light comes from the left, you need to mask the highlights on the left side of the nectarines as well as the various highlights in the silver. Use masking fluid to protect the reflections of the white lace in the silver. Leave patterned gaps in the lace for the wood to show through.

Once the lightest areas are protected, use your no. 8 round to paint a wash of Quinacridone Gold on the nectarines. While this wash is still wet, use your no. 6 round to gently brush Burnt Sienna into the nectarines on the side facing away from the light. The wet-in-wet technique is ideal for the diffused form shadows. Don't forget to paint the reflections of the fruit. Repeat the techniques and colors for the reflections.

Finally, use your mop brush to apply a wash of Cobalt Blue to the pieces of silver and the lace.

2 BUILD THE COLOR | Create a warm mixture of Alizarin Crimson with Burnt Sienna on your palette. After wetting the nectarines with clear water, apply a wash of this warm color using your no. 8 round. Apply less color in the lighter areas, but do a second pass of color in the modeled shadows. If you apply too much color in the lighter part of the fruit, blot the wet paint with a folded paper towel, lightly pulling towards the edges. Drybrush some of the warm mixture into the reflected nectarines.

For the wood reflected in the teapot, create a mixture of Burnt Sienna and Antwerp Blue. Fill in the gaps in the lace with this mixture using a no. 6 round. Apply a wet-in-wet wash into the teapot to indicate the reflected tabletop. Don't use this mixture for the actual tabletop, just the reflections. Apply a wash of Winsor Violet to the dark edge of the table with your no. 8 brush. For the tabletop, use Burnt Sienna.

You need to create the neutral gray for your silver washes. On your palette, mix Antwerp Blue with small amounts of Burnt Sienna and a touch of Alizarin Crimson. Wet the silver objects one piece at a time with clear water. For each piece, load your brush with the neutral gray and drop the color into the darkest area first using your no. 8 brush.

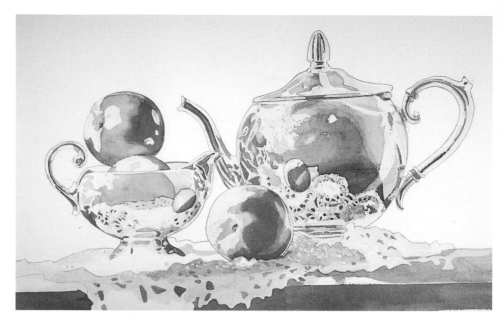

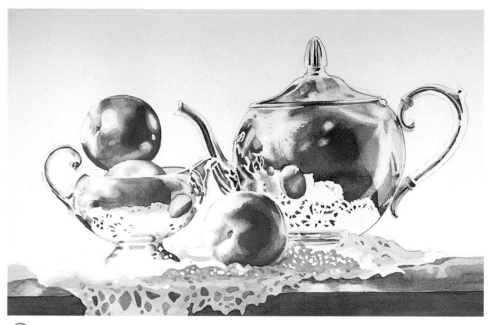

3 ESTABLISH THE VOLUME | Remove the masking fluid. Smooth out any hard edges with a wet scrubber brush and blot with a paper towel. At this point, the painting has little value contrast, but that will change.

With your no. 6 round, add another Burnt Sienna wash mixed with a touch of Vermilion to the darkest areas of the nectarines. Focus this color on the middle and right of the fruit, but leave the highlights and light areas untouched. Paint a smaller area with each successive wash to suggest the nectarine's form.

Paint a wash of Quinacridone Gold over the Winsor Violet on the edge of the table. With your mop brush, add a wash of Antwerp Blue to the lace hanging over the edge.

You also need to add another layer of the neutral gray to the silver. If you need more of the color, mix more Antwerp Blue with a small amount of Burnt Sienna and a touch of Alizarin Crimson. Use the method of smaller and smaller successive washes to form the silver pieces, concentrating more on the middle of the teapot and creamer.

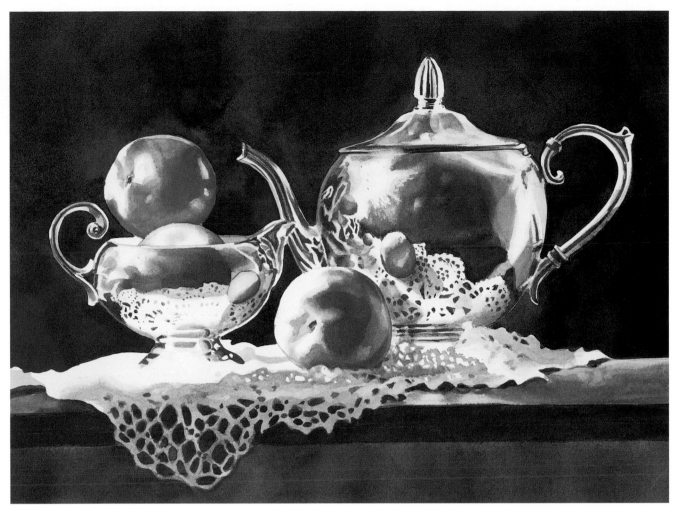

Nectarines and Tea
12" x 18"
(30cm x 46cm)

4 ADD THE DETAILS AND THE BACKGROUND I Add some final details. Use your no. 6 round to accent the area surrounding the stem of the tabletop nectarine with rich New Gamboge. To darken the table and connect it more with the reflection, layer the tabletop with a mixture of Antwerp Blue and Burnt Sienna with your no. 8 round. Study your reference material, then carefully paint the patterns of the lace with the table color. Darken the table a bit by adding a mixture of Burnt Sienna and Winsor Violet. Paint the small shadows beneath the lace. Use your no. 6 round to create the details in the silver with a darker mixture of the neutral gray.

To create the background, you'll need to apply thick washes of Antwerp Blue, Burnt Sienna and Alizarin Crimson, using a different mop brush for each color. Lay down at least three layers of each color to achieve the velvety quality of the background.

Mixing Paint

I keep my basic colors in the palette wells with a tablespoon of water already added. Since my palette has a lid, the paints don't dry out. I just have to stir before I paint each day. When I tell you to mix the paint on your palette, I want you to load a brush with one color, drop it in the clear area of your palette and rinse the brush. Add a second color with the cleaned brush. Use this same brush to mix the two colors together. Vary the value of this color by adding more water to lighten it, adding more of one color to deepen it, or letting it dry out a bit and rewetting it the next day (this will make it more concentrated and darker).

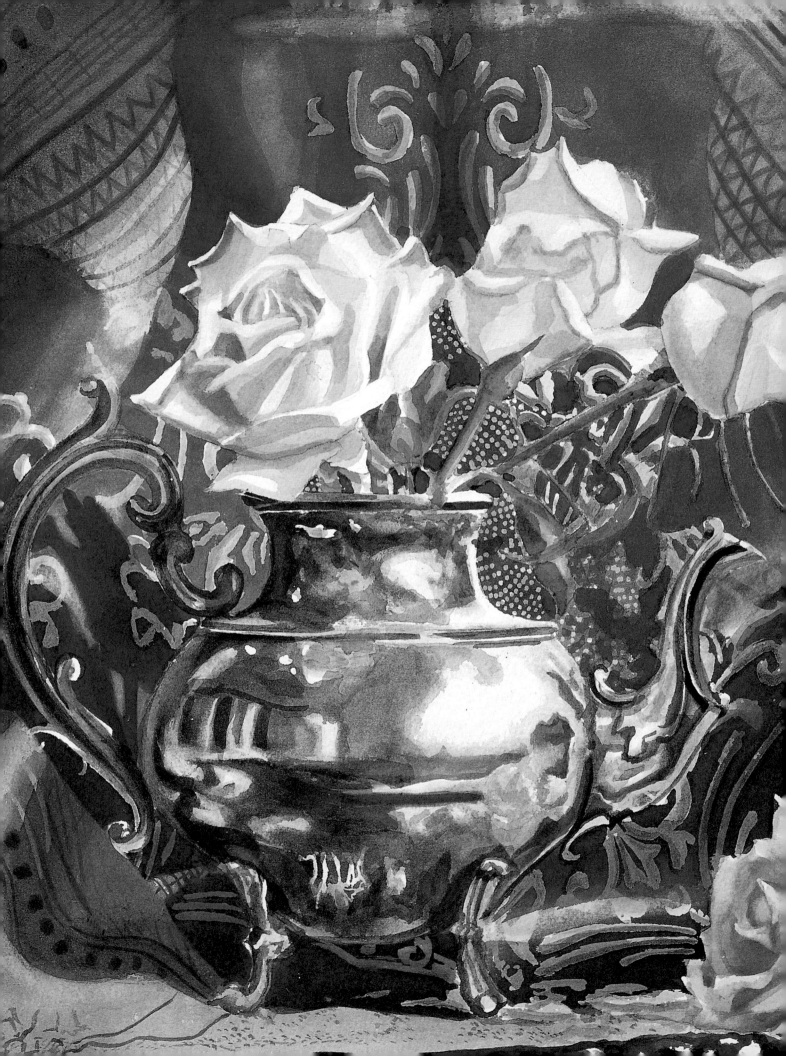

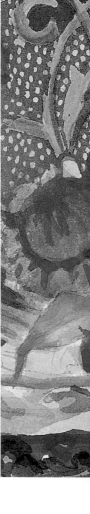

Texture Step by Step

"It looks so real. I just want to touch it!" That's the most common response I hear to my paintings. I love hearing it because it means that I've succeeded in depicting the tactile nature of the everyday things. In my attempt to teach this to you, I will show you how to paint one type of texture at a time in the context of a whole painting. Enjoy!

Everlasting Beauty
17" x 24" (43cm x 61cm)

Dramatic Background

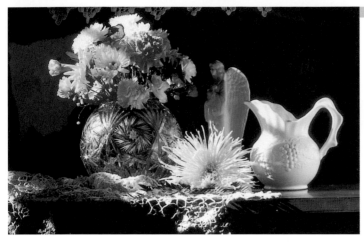

THIS IS A MARVELOUS TECHNIQUE for creating a dramatic environment for your still life. The wash layers mingle to create an array of velvety, jewel-like colors. Repeat colors already found in the subjects in order to add a strong harmonizing influence, but limit yourself to three colors. Too many colors will ruin the affect.

The technique takes swiftness and concentration, so make sure that you are free from interruptions by children, pets, spouses and telephones. It may take several paintings, but you will soon have the confidence to hold two loaded mop brushes in one hand and paint with the other!

Preparing to Paint

Apply masking fluid along the edges of all objects that might be in your way when you paint the background. Consider the masking tape on the painting's borders and masking fluid on the subjects' edges as "home base," where your brush can start and stop.

In three small cups or in your deep-welled palette, make three separate washes of Burnt Sienna, Alizarin Crimson and Antwerp Blue. The consistency should be about as thick as honey. Don't be afraid of making too much of one color—it won't go to waste.

Be sure to begin this process on a flat surface. Don't tilt your painting at any point in this process because it will cause the paint to mix and mingle too quickly.

Materials

PAPER
Arches 140-lb. (300gsm) cold press

PAINT
Alizarin Crimson
Antwerp Blue
Burnt Sienna

BRUSHES
Mop brushes (3)
No. 4 round

OTHER MATERIALS
Masking fluid
Masking tape
Rubber cement pickup

1 **PAINT THE FIRST WASH** I Load a mop brush with Burnt Sienna and start in the top left corner. Drag your brush from left to right creating roughly a 4" × 4" (10cm × 10cm) patch of color. Pick up a clean mop brush and quickly load it with Alizarin Crimson. Start where your Burnt Sienna wash ended and make another patch of color. Load the next clean mop brush with Antwerp Blue and introduce it to the bottom of the Alizarin Crimson wash. Repeat the process until your background is filled with color. Let the painting dry flat overnight. This first wash is going to look strange to you, but have faith. Don't go back over any areas!

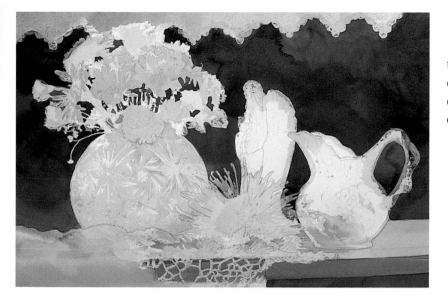

2 ADD ANOTHER LAYER | Repeat the process, but this time change the order of the colors that you lay down. For example, put Alizarin Crimson over your Burnt Sienna wash from Step 1. You'll notice different colors start to emerge as they are layered over each other. Let everything dry.

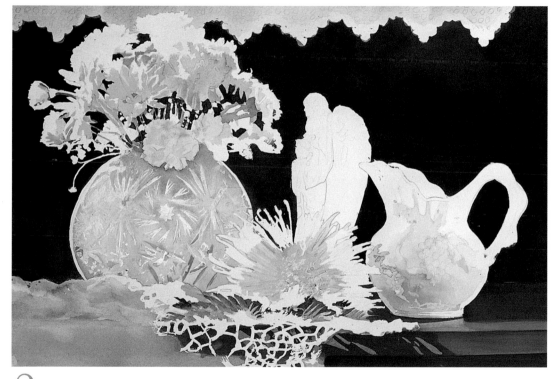

3 DEEPEN AND DARKEN | Repeat Step 2 by once again alternating colors. Once this third layer is dry, you can determine if the background needs more color. I've done as many as five consecutive layers. When you are satisfied with the results, carefully remove the masking fluid with a rubber cement pickup.

Pooling Paint

Carefully blot any pooling paint that forms in the masked areas and on the masking tape edges. This will keep the paint from blooming back into your painting.

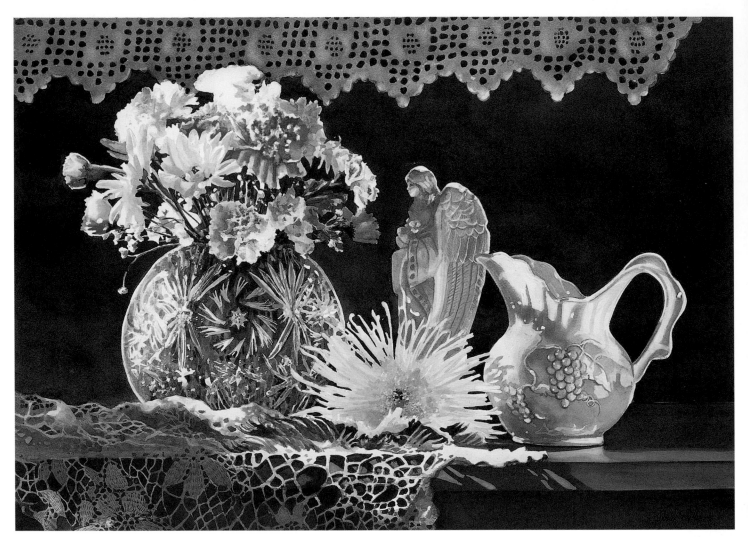

4 **CLEAN THE EDGES** | You might notice choppy edges on some of your still life subjects. To clean up these edges, activate some of the darkest, dried color along the taped edges of the painting by wetting it. Using your no. 4 round and this paint, reinforce the edges of your subjects.

Crystal Vase
20" x 27"
(51cm x 69cm)

Lace

OUT OF ALL THE THINGS I PAINT, people are most intrigued by the lace in my paintings. The secret to painting lace is that you paint the holes and, in most cases, paint them last. This stands true, whether you're painting crochet lace or cutwork lace. In the first steps, you concentrate on painting the folds and the shadows of the cloth itself. Only in the final stages do you see it all come together as lace. I will admit that sometimes I do cheat a little bit by applying a light wash in some of the lace holes early on just to give me an idea of how good it will look at the end.

Materials

PAPER
Arches 300-lb. (640gsm) cold press

PAINT
Alizarin Crimson
Burnt Sienna
Cobalt Blue
Quinacridone Gold
Winsor Violet

BRUSHES
Mop brush
Nos. 4, 6, 8 round
Scrubber brush

OTHER MATERIALS
Hair dryer
Masking fluid
Paper towels
Rubber cement pickup

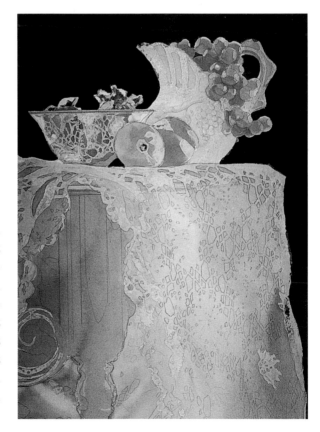

1 LAY IN COLOR | Protect the highlighted areas of the lace with masking fluid. In this case, some of the lace holes were masked out by mistake. They get filled in later. (Sometimes, I end up saving too much of the paper!) Once the masking fluid is dry, wet the lace with clear water, then use your no. 8 round to drop Cobalt Blue into the folds. Tap your brush gently on a paper towel to bleed the excess paint away. While the paper is still wet, apply Cobalt Blue in streaks that follow the folds of the lace. Let this dry completely, allowing the Cobalt Blue to settle into the paper. Wet the lace again with clear water, then load your mop brush with Alizarin Crimson and add it in a fluid motion to the far right portion of the fabric. Let everything dry.

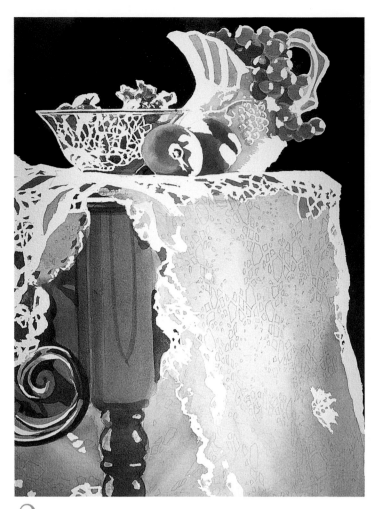

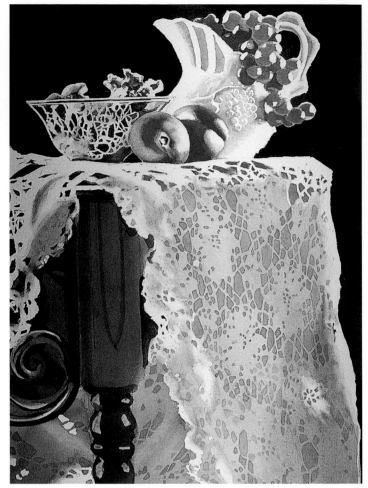

2 CREATE THE FOLDS | Load your mop brush with a little Quinacridone Gold, then glaze a light, even wash over all of the colors you applied to the lace earlier. Not only does this give the fabric its weight, but the Quinacridone Gold mingles with the Cobalt Blue and Alizarin Crimson to create a fuller range of colors. Add two extra layers of Quinacridone Gold to the fabric that appears under the table. The darker value you create there will give that part of the lace the illusion of being farther away. Once these layers have dried, use your rubber cement pickup to remove all of the masking fluid.

3 FILL IN THE HOLES | Use your moistened medium size scrubber brush to scrub and blot the hard edges left behind by the masking fluid. Dry everything with a hair dryer before moving on to the next step. On your palette, mix Quinacridone Gold with Burnt Sienna. Add a good bit of water to dilute the mixture, lightening it. Use your no. 6 round to fill in the lace holes that you penciled in. This lighter mixture suggests the wood, but isn't as dark as it will be. At this point, you're only creating a basic map for yourself. You'll intensify the color in select areas next.

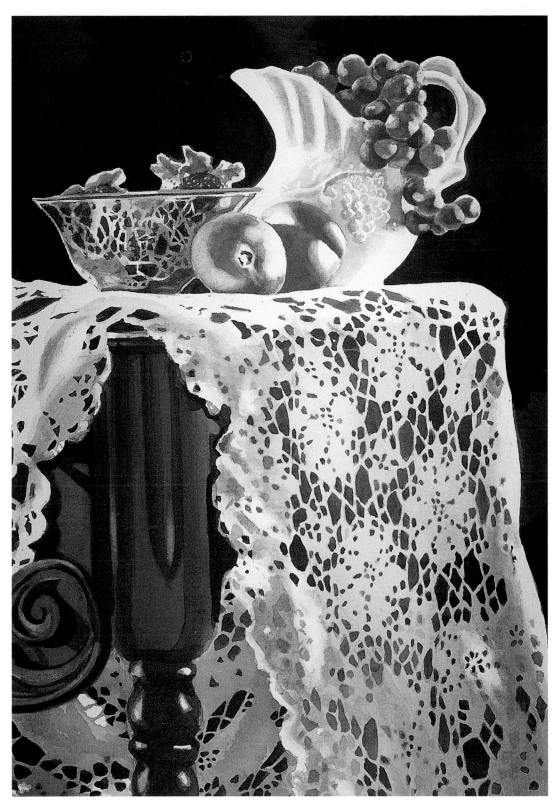

Fruits and Lace
17" x 12" (43cm x 30cm)

4 DARKEN THE HOLES | Mix Burnt Sienna and Winsor Violet, but use very little water. With your no. 4 round, dry-brush this color into the lace holes that have wood behind them. This is also a good time to clean up the rough edges that the masking fluid may have left. Add more Winsor Violet to the wood mixture, then use this to paint a second coat over the very darkest holes. This will help vary the darkness of the holes according to how the wood of the table appears behind the lace. This variation will keep the lace from appearing "flat."

Embroidered Silk

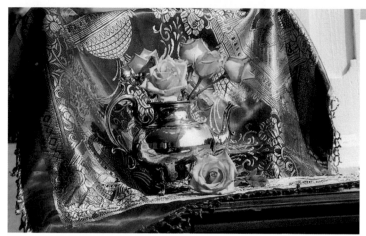

THE MARVELOUS SHEEN OF THE SILK, the texture of the embroidery and the wonderful contrast of the blue and gold made me decide to buy and use this cloth in a painting. When setting up the still life, I looked for items that would provide a contrast for the cloth as well as echo the silk's embroidered designs. The teapot's handle and spout repeated the embroidered curves and the real roses emphasized the embroidered ones.

To create the texture of embroidered silk realistically, you must purposely leave the folded areas several shades lighter than the rest of the cloth. This will give the silk its shine. The embroidery will take its shape if you use a light base color and exaggerate the shadow on one side of the embroidered area. The darker the shadow, the more three-dimensional the stitching will look.

Materials

PAPER
Arches 300-lb. (640gsm) cold press

PAINT
Antwerp Blue
Burnt Sienna
Cobalt Blue
Quinacridone Gold
Ultramarine Blue
Winsor Violet

BRUSHES
Mop brush
Nos. 4, 6, 8 round
Scrubber brush

OTHER MATERIALS
Masking fluid
Paper towels
Rubber cement pickup

1 **START WITH LIGHT LAYERS OF COLORS** | Mask out the embroidered areas that are in the light. Wet the entire cloth area with a mop brush and then drop Winsor Violet into the deep shadows. While the area is still wet, use Cobalt Blue in the lighter folds and Burnt Sienna in the shadow of the teapot. Let everything dry. Mix Antwerp Blue with Winsor Violet, then paint a dark wash with your no. 8 round over the foreground fringe and the shadow under the teapot.

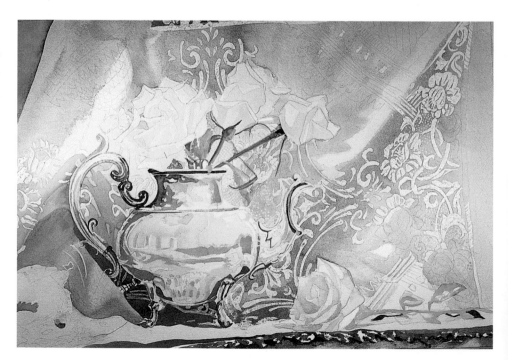

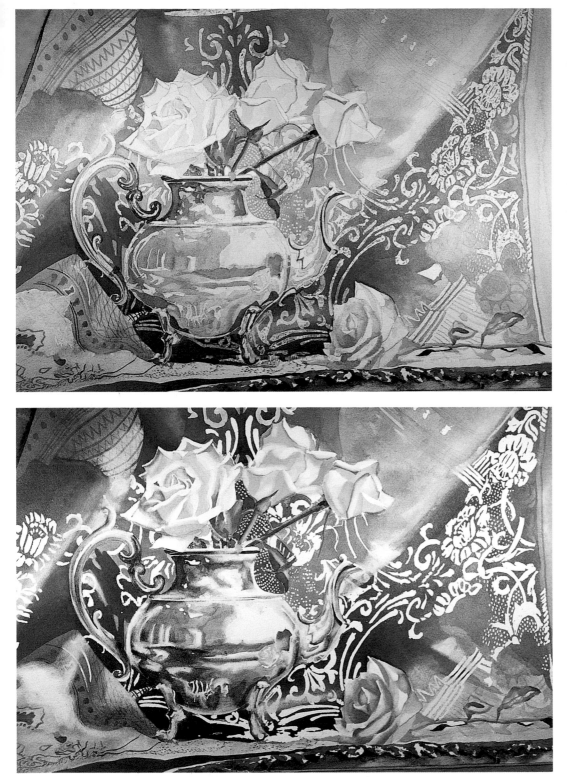

2 BUILD THE COLOR WITH GLAZES | Mix Antwerp Blue, Ultramarine Blue and Winsor Violet on your palette. Wet the entire cloth area, then wait about thirty seconds for the water to soak in. Load your mop brush with the paint mixture and blot the brush lightly on a paper towel. Add the color to the deepest folds in the silk. If the mop brush is too clumsy for the smaller areas, switch to the no. 8 round. Let everything dry. To paint some of the silk's details in the upper and lower left of the painting, use this mixture and your no. 8 round, painting wet-on-dry.

3 DARKEN THE SILK WITH MORE GLAZES | Add more glazes of the deep blue mixture to the shadows until you feel that the contrast between light and dark areas is correct. Let everything dry. At this point, go back to the lightest areas of the silk (those that would be folded out towards the viewer) and use a wet scrubber brush and a paper towel to gently scrub and blot these areas so the highlight is a little more exaggerated and well-blended. Once this is dry, remove the masking fluid from the embroidered areas of the cloth.

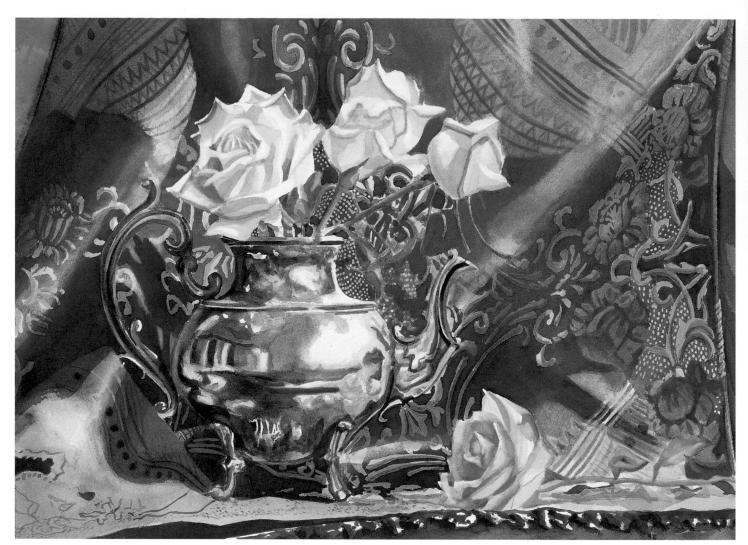

4 **PAINT THE EMBROIDERY** | Use your no. 8 brush to add Cobalt Blue to the areas of the blue stitching. Use the same brush to add Quinacridone Gold mixed with a little Burnt Sienna to the gold stitching. Wait for everything to dry, then mix Winsor Violet with some Cobalt Blue and use a smaller round brush to add a shadow stroke to the dark side of each blue-colored stitching. This may take two coats. Add Winsor Violet to the Quinacridone Gold and Burnt Sienna mixture and paint the same shadow stroke on the gold-colored stitching.

Silver Teapot

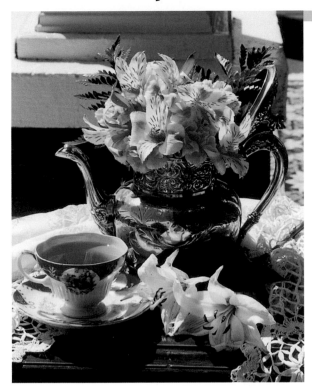

I **SET UP THIS STILL LIFE** outside on a cool September morning. I didn't have enough light in my kitchen to capture the translucency of the flower petals and the tea, so I carried everything outside. I had to deal with the wind blowing the flowers around, but the blue sky reflected beautifully in the silver teapot, harmonizing with the teacup.

Most artists are overwhelmed by the thought of painting something as complex as silver. It's actually quite fun to paint because it reflects absolutely everything around it. To make it look real, you have to use a variety of techniques, including wet-in-wet for the silver, then drybrush strokes for the details and reflections.

Materials

PAPER
Arches 300-lb. (640gsm) cold press

PAINT
Alizarin Crimson
Antwerp Blue
Burnt Sienna
Cobalt Blue
Hooker's Green
Permanent Rose
Ultramarine Blue
Winsor Violet

BRUSHES
Mop brush
Nos. 4, 6, 8 round
Scrubber brush

OTHER MATERIALS
Masking fluid
Paper towels
Rubber cement pickup

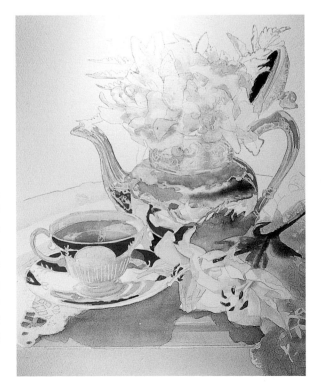

1 **SET THE TONE** | After masking out all of the highlights, wet the whole teapot with water and use your mop brush to lay down a wash of Cobalt Blue. Let everything dry. Add the dominant reflections as a wet-in-wet wash with your no. 6 round. In this painting, your dominant reflections will be the teacup (use Ultramarine Blue), the flowers (use Permanent Rose), and the lily stems (use Hooker's Green). Once those washes are dry, create a neutral gray on your palette using Antwerp Blue, Burnt Sienna and a touch of Alizarin Crimson. Wet the teapot and add the gray with your no. 8 round. Allow everything to dry.

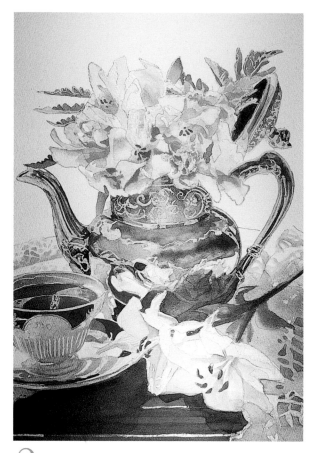

2 SOLIDIFY THE TEAPOT | Create an even darker gray consisting of mostly Antwerp Blue and adding Burnt Sienna, Alizarin Crimson, Hooker's Green and Winsor Violet. If the color goes off into the green range, add more Antwerp Blue and it should bring you back to dark gray. Wet the teapot with clean water and use your no. 8 round to add the darker gray to the darkest areas of the teapot. Once this is dry, use the same brush and mixture to do wet-on-dry strokes on the rim and handle areas.

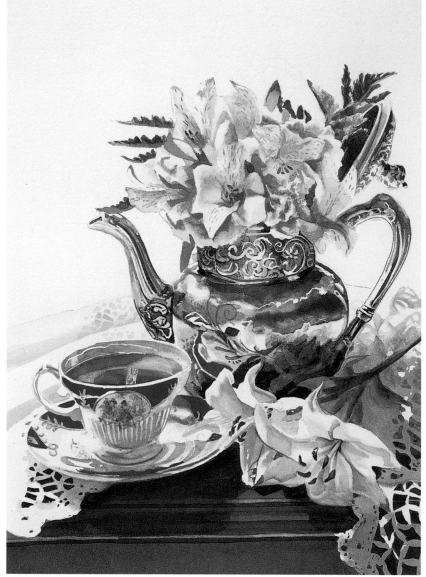

Four O'Clock
18" x 14"
(46cm x 36cm)

3 REFINE THE IMAGE | Remove the masking fluid. Soften any hard edges within the teapot using a wet scrubber brush. Blot the area with a paper towel. Add Winsor Violet to the neutral gray on your palette to darken it. Using your no. 8 round, paint the darkest darks of the teapot. Use your no. 4 round to paint the small details with the dark gray. Look carefully at the reflections in the teapot and use the wet-on-dry detail technique to exaggerate them. Don't cover the whole teapot in paint; you want to leave some of the white of the paper. Step away from your painting often and look at it from several feet away during this final process to gauge your progress.

Polished Wood

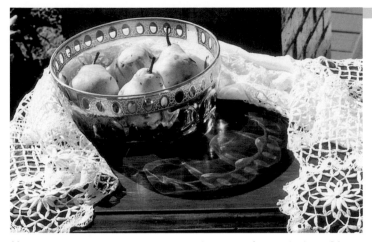

YOU MIGHT NOTICE THIS TABLE in many of my paintings. I have probably painted it hundreds of times; it's small, portable and has just the right warm amber coloring that I like to have in a painting. It also has great sentimental value for me because it's the first antique I ever bought.

When you prepare to paint a flat surface of polished wood, mentally put the reflections in two different categories. The first category includes reflections in a surface that are cast by objects. These reflections should be masked, but will probably need a glaze of brown at the end. The second category of reflection is the light the table reflects, the highlights. These reflections are also masked out, but will often remain white with softened edges.

Materials

PAPER
Arches 300-lb. (640gsm) cold press

PAINT
Burnt Sienna
Cobalt Blue
Quinacridone Gold
Winsor Violet

BRUSHES
Mop brush
No. 8 round
Scrubber brush

OTHER MATERIALS
Masking fluid
Paper towels
Rubber cement pickup

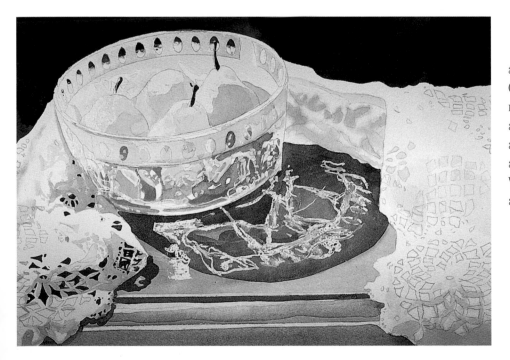

1 **LAY THE FOUNDATION |** After masking out all highlighted areas, apply two consecutive glazes of Quinacridone Gold to the table with your mop brush. When the two glazes have dried, apply a wash of Burnt Sienna to the shadow area. Let this dry before following with another wash, but this time add a touch of Winsor Violet to the Burnt Sienna before applying it.

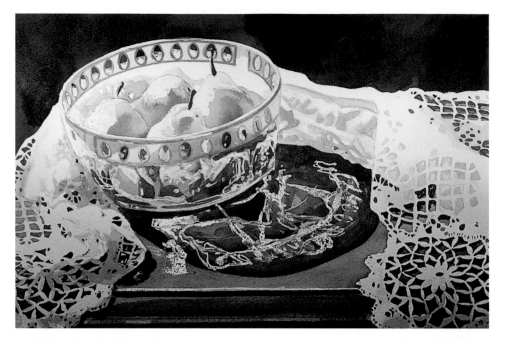

2 DARKEN THE WOOD | To pull the colors of the tabletop together, you need to lay down a unifying wash. Create a mixture of Burnt Sienna and Winsor Violet on your palette, then use your mop brush to paint the whole table area with this color in one continuous wash.

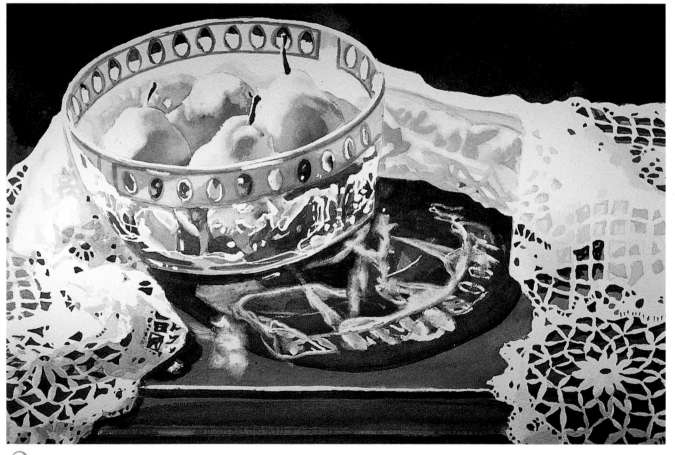

3 SOFTEN THE EDGES OF THE REFLECTIONS | With your rubber cement pickup, remove the masking fluid. You don't want any hard edges, so use a large wet scrubber brush and a paper towel to scrub and blot the edges of reflections.

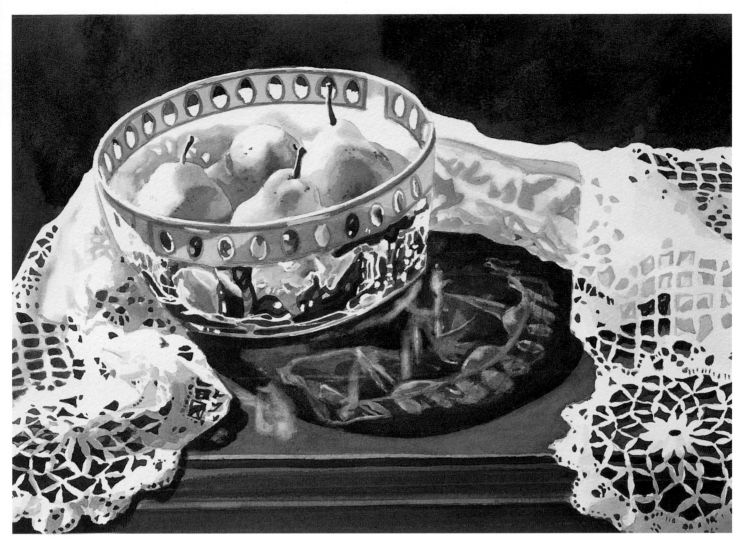

4 SEPARATE THE REFLECTIONS WITH COLOR | Once you have let the scrubbed reflections dry, add a light wash of Burnt Sienna to the cast reflection from the glass bowl. Let this dry, then use your no. 8 round to add Cobalt Blue to the vertical highlights coming from the polish on the wood. A wash of Cobalt Blue will add a cool note to an otherwise warm painting and bring the painting together.

Four Pears
11" x 16"
(28cm x 41cm)

Pearls

Materials

PAPER
Arches 300-lb. (640gsm) cold press

PAINT
Alizarin Crimson
Cobalt Blue
Quinacridone Gold
Winsor Violet

BRUSHES
Nos. 4, 6 round

OTHER MATERIALS
Masking fluid
Rubber cement pickup

PEARLS COME IN MANY DIFFERENT SHADES and colors. I chose some antique pearls that belonged to my husband's grandmother for this demonstration. Their true color is a creamy beige, but once I really studied them, I noticed pinks, blues and warm yellows depending on what other objects I placed around them. The trick to painting pearls is to create many tiny highlight spots on each pearl with masking fluid and to exaggerate the shadow to give the feeling of roundness.

I always add more masking fluid spots than I will need because I've learned that once you put the color down, it's hard to go backwards and remove it. If the pearls look too shiny when you remove the masking fluid, you can always fill the excess white spots with a light value of the surrounding colors.

1 BUILD A BASE | Use a small brush, like a no. 4 round, to mask out the highlights on the pearls. Remember that it's better to mask out too much than too little. Once you've applied enough masking fluid, make sure you clean the brush thoroughly. Wait for the masking fluid to dry, then apply a wet-in-wet wash of Winsor Violet on each pearl where the deepest shadow will be. Once that wash is dry, glaze each pearl with a light wash of Quinacridone Gold.

2 SCULPT WITH COLOR | Add a second coat of Quinacridone Gold. While this wash is still wet, use your no. 4 round to drop in a touch of Alizarin Crimson at the bottom shadow of each pearl. Let this dry. With your no. 6 round, use a wet-on-dry stroke to add Winsor Violet around the largest highlight spots.

3 MAKE IT SPARKLE | Remove the masking fluid using your rubber cement pickup. Use some Cobalt Blue and cover one or two of your unmasked highlights to help them sparkle. If you feel you need to, adjust some of your other colors to create more contrast.

Heirlooms
11" x 14"
(28cm x 36cm)

Porcelain Teacup

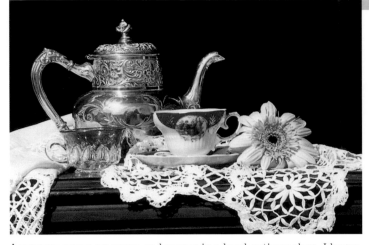

I **FOUND THIS TEACUP** and saucer in a local antique shop. I began collecting single teacups years ago because I never know when I'll need that extra little item in a composition. These lonely teacups and saucers are usually quite inexpensive because they are no longer part of a set. The illustration of the people on the cup brings in a human element. The bright blue of the cup is so vibrant that it becomes the focal point.

Teacups make great subject matter for artists. The challenge is in re-creating their intricate designs and delicate handles. The local color of the cup always goes on first, followed by the shadows. The fun part is saved for last: only at the end do you get to paint the design and add extra punch with the gold trim details.

Materials

PAPER
Arches 300-lb. (640gsm) cold press

PAINT
Alizarin Crimson
Antwerp Blue
Burnt Sienna
Cobalt Blue
Permanent Rose
Quinacridone Gold
Sap Green
Ultramarine Blue

BRUSHES
Nos. 4, 6, 8 round

OTHER MATERIALS
Hair dryer
Masking fluid
Rubber cement pickup

1 **APPLY LOCAL COLOR** | First, apply masking fluid to the areas that will remain white or light, such as the highlights on the cup. Then, using your no. 6 round, apply a light wash of Cobalt Blue to the colored areas of the cup. Dry this with a hair dryer, and follow with a wash of Ultramarine Blue. With your no. 8 round, paint a light wash of Quinacridone Gold over the lower area of the cup and saucer. Once the Quinacridone Gold wash is dry, wet the area with clean water and drop Alizarin Crimson in the curvy, shadowed area of the cup, handle and saucer. Let this dry, then add some Cobalt Blue to the lace reflection in the bottom of the saucer.

2 MORE GLAZES | Mix Ultramarine Blue with some Antwerp Blue and lay a wash on the colored area of the cup. Add a wet-in-wet wash to the curved area of the cup and saucer bottom using Alizarin Crimson, then some Cobalt Blue. Use your rubber cement pickup to remove masking fluid. Painting wet-on-dry and using a mixture of Quinacridone Gold and some Burnt Sienna, paint the gold trim on the edges and in the details of the cup. Leave a white highlight where the light hits the front of the cup.

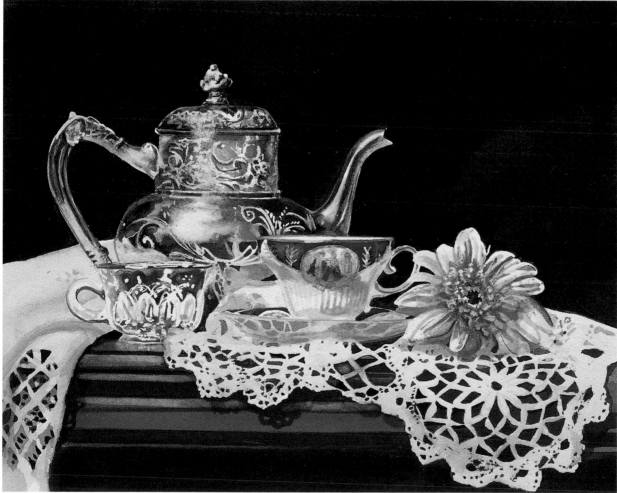

3 BUILD THE COLORFUL RESULTS | Add a layer of Ultramarine Blue and Cobalt Blue to the top of the cup and saucer. Use your no. 4 round to add Burnt Sienna to the dark detail in the gold trim. To create the reflection of the daisy, lay a light wash of Permanent Rose over the right side of the cup. Finish with the details that are actually printed on the cup using Alizarin Crimson, Quinacridone Gold and Sap Green.

The Cup for Me
14" x 17" (36cm x 43cm)

Apples

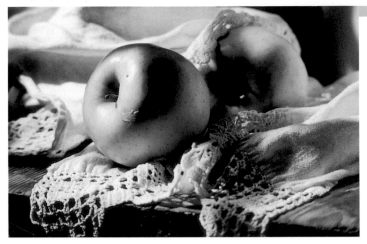

THE TRADITIONAL WAY to paint watercolor is from light to dark, but you don't always have to do it that way. The way I'm going to teach you to paint apples is by underpainting the shadows first. Create the green color of the apples by glazing multiple layers of different blues and yellows, then accenting with Sap Green at the very end.

The apples were strategically placed so that they intersected with each other, creating a flow of movement through the painting. I tilted the apples in different directions, one at a 45-degree angle and the other pointing at the viewer, to add interest and direction. This painting is a good study of the different types of shadows. The lighting creates strong cast shadows, as well as clear highlights.

Materials

PAPER
Arches 300-lb. (640gsm) cold press

PAINT
Antwerp Blue
Burnt Sienna
New Gamboge
Sap Green
Winsor Violet

BRUSHES
Mop brush
Nos. 6, 8 round
Scrubber brush

OTHER MATERIALS
Hair dryer
Masking fluid
Paper Towels
Rubber cement pickup

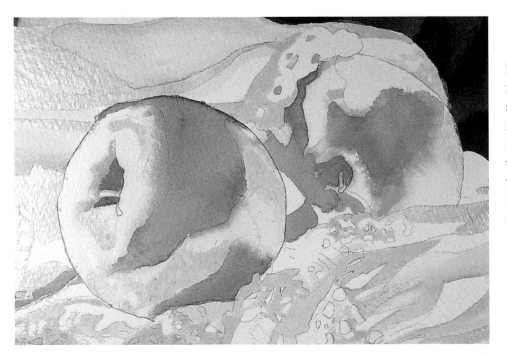

1 UNDERPAINT THE APPLES WITH BLUE I Mask out all of your highlights. Wet one of the apples with your mop brush, giving the water about thirty seconds to soak in. While you wait, load your no. 8 round with Antwerp Blue and drop it into the shadow areas of the apple. Dry with a hair dryer, then repeat the process with the second apple. When both apples are completely dry, glaze them both with a second layer of Antwerp Blue.

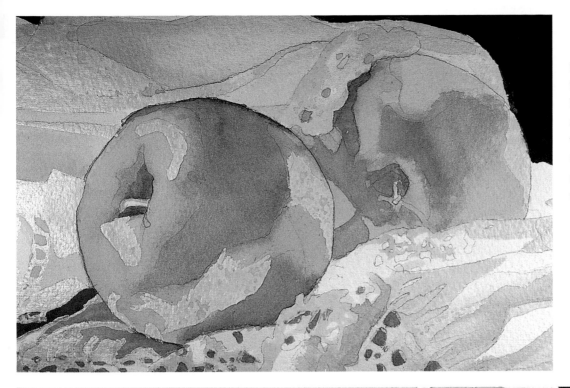

2 **GLAZE WITH YELLOW |** Glaze both apples with two layers of New Gamboge. Dry the layers with the hair dryer between coats. Use your no. 8 round to darken the stem areas with more Antwerp Blue. Also use more Antwerp Blue along any outside edges of the apples that are in shadow.

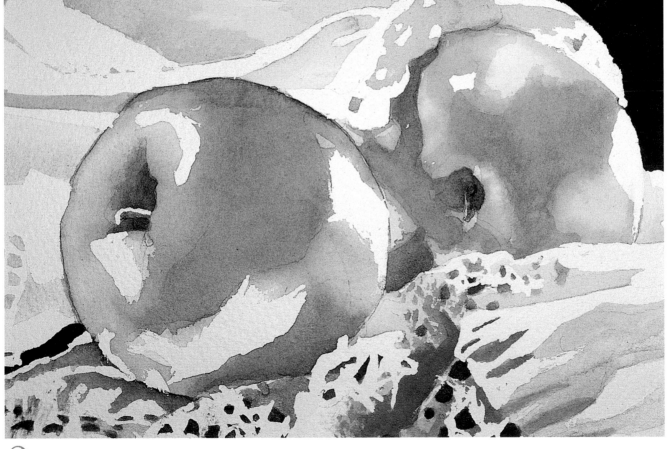

3 **ADD THE FINAL GLAZES |** For the final glaze, load your mop brush with Sap Green and lay a wash over both apples. Let this dry. Mix Burnt Sienna with a touch of Winsor Violet. Paint the edge of your stems with this mixture and your no. 6 round. Remove the masking fluid with a rubber cement pickup.

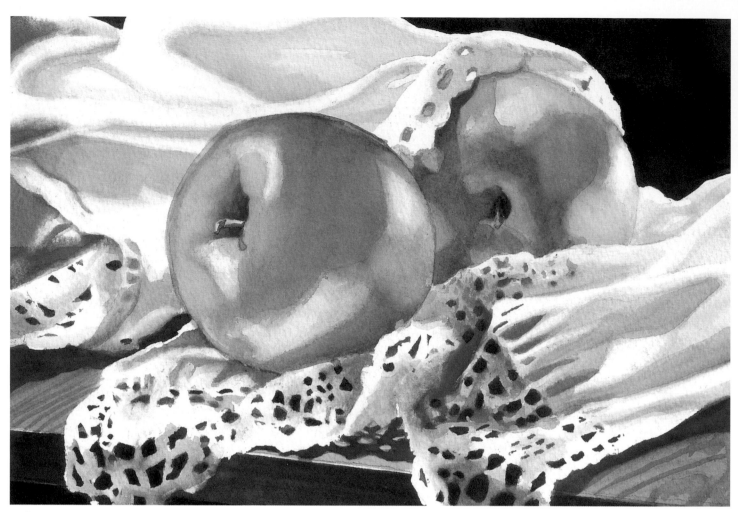

4 SOFTEN THE HIGHLIGHTS | Use your scrubber brush and a paper towel to soften the hard edges of the highlights. Dry everything with the hair dryer. Add a light wash of New Gamboge in some of the highlight areas.

Golden Delicious
8" x 12"
(20cm x 30cm)

Roses

I CAME UPON THESE TWO ROSES in the botanical gardens in my area. The season for roses was ending, but these two were still fresh and crisp. The noon sun was directly overhead putting just the right highlights on the flowers and really deep purplish blue shadows on the lower petals. The local color matched Holbein's Opera so closely that I couldn't get wait to get home to paint!

The secret to making these pink roses jump off the page is to create high value contrast between the background and the lightest petals. Even though these are pink roses, the lightest petals are actually white with just enough pink in the shadow areas to give them form. This wouldn't have been possible without a dark background to "frame" the roses.

The texture is achieved at the end of the painting when the masking fluid is lifted. The scrubbing and blotting techniques soften the rounded edges on each petal. The only hard shadow edges should be from the cast shadows.

Materials

PAPER
Arches 300-lb. (640gsm) cold press

PAINT
Antwerp Blue
Burnt Sienna
Hooker's Green
New Gamboge
Opera (Holbein)
Permanent Rose
Quinacridone Gold
Quinacridone Red

BRUSHES
Mop brush
Nos. 6, 8 round
Scrubber brush

OTHER MATERIALS
Hair dryer
Masking fluid
Paper towels
Rubber cement pickup

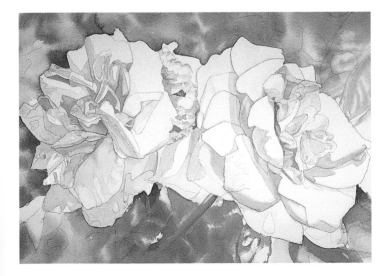

1 GETTING STARTED | Mask the edges of petals that are hit with light. Use your no. 8 round to paint a fairly concentrated wash of Quinacridone Gold over the center of each flower. Wait for the Quinacridone Gold to dry, then lay a wash of Permanent Rose over this area and to the middle and lower half of each rose. Wet the background with a clean mop brush, then randomly drop in Antwerp Blue and Quinacridone Gold. Touch the brush to the paper in several different areas. Let the color spread on its own.

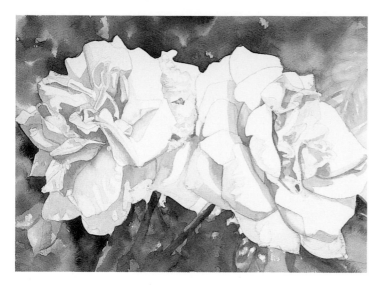

2 DEEPEN AND DARKEN | Mix Permanent Rose and Quinacridone Red on your palette. Paint washes of this mixture over the shadow areas where one petal overlaps another and where petals meet. For the background, add a little Burnt Sienna to Hooker's Green. Wet the background with clear water, then drop in some of the mixture, just touching the paper and letting the paint bloom.

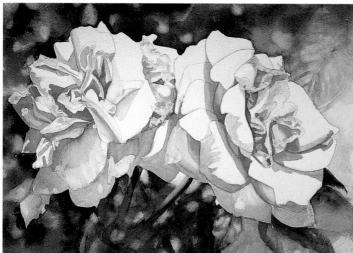

3 BUILD THE SHADOWS | Use your mop brush to apply a wash of Antwerp Blue to the deeply shadowed parts of each flower. Dry this with your hair dryer then paint a wash of Permanent Rose over the same areas. Using your no. 6 round and a mixture of Burnt Sienna and Permanent Rose, define the dark areas between petals with an even, fairly thick wash. Add another wet-in-wet wash of Hooker's Green to the background and use your no. 6 brush around the delicate petals to get a crisp edge.

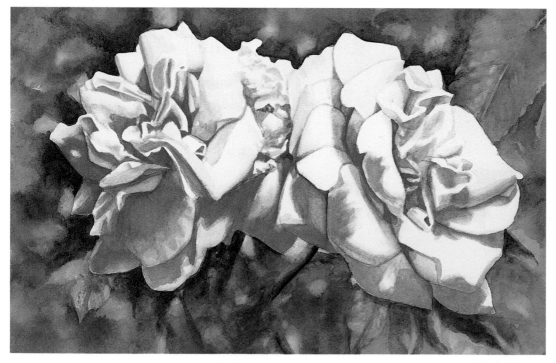

4 CREATE THE SOFT PETALS | Remove the masking fluid. You'll want to keep the hard edges on the cast shadows, but soften the other edges with a wet scrubber brush. Scrub the edges, then blot them with a paper towel. Once the scrubbed areas are dry, add Opera in a wet-in-wet wash to the folds of curled petals. Be careful not to over-indulge in the use of Opera; this strong color can easily overpower the painting. At this point, you should step back from the painting to gauge whether you need to adjust the values. If you feel the roses need a warmer glow, glaze New Gamboge over some of the deep pinks emanating from the flowers' center.

Pink Roses
12" x 18"
(30cm x 46cm)

Amaryllis

Materials

PAPER
Arches 300-lb. (640gsm) cold press

PAINT
Antwerp Blue
Cadmium Red Light
New Gamboge
Permanent Rose
Quinacridone Red
Winsor Violet

BRUSHES
Mop Brush
No. 8 round
Scrubber brush

OTHER MATERIALS
Masking fluid
Paper towels
Rubber cement pickup

THESE FLOWERS ARE broad trumpets of color with translucent, fleshy petals that are begging to be painted. The final result involves layers upon layers of paint, but the red of the flower only becomes evident in the final stages of the painting. Cadmium Red Light is an opaque color, so it needs to be handled carefully. As an opaque paint, it could potentially obscure all the hardworking layers of color beneath it, so it needs to be heavily diluted. Still, it's worth it; building the rich red from all those layers and then adding Cadmium Red Light will bring the color to life.

These huge flowers have many interesting shapes, both sharp and soft. I took several photos and combined two to get this painting. I liked the open flowers in one, but I also like the forward-facing bud in another. Always ask yourself if you can improve a composition by combining reference photos.

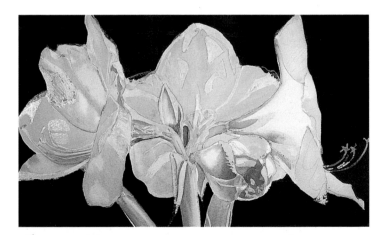

1 **UNDERPAINT THE FLOWERS** | Mask the extreme highlights on the flowers and stems, then use your mop brush to wet each flower with clean water. Load your no. 8 round with concentrated Winsor Violet (lots of paint and very little water). Using only the tip of the brush, add this color wet-in-wet to the darkest areas of each flower head, including the unopened buds. Once the Winsor Violet has dried, use your mop brush to lay a wash of New Gamboge where the light glows through the petals. Let this dry, then add a second coat of New Gamboge. Lay Antwerp Blue over the stems, then follow with two coats of New Gamboge.

89

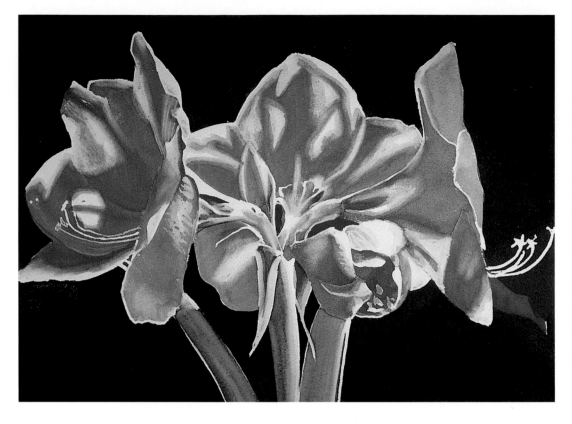

2 **MIXED REDS** | On your palette, mix Quinacridone Red and Permanent Rose. Wet one flower at a time with clean water, then use your no. 8 round to add the mixed red. Start in the darkest areas first and work slowly, letting the color bleed out into the lighter areas. If too much red seeps into an area that you wanted to remain light, simply grab a paper towel and blot the paint away. Let everything dry, then remove the masking fluid using your rubber cement pickup. Leave the edges of the flowers hard so the boundaries are clear, but use a scrubber brush to soften the highlights' edges within the petals.

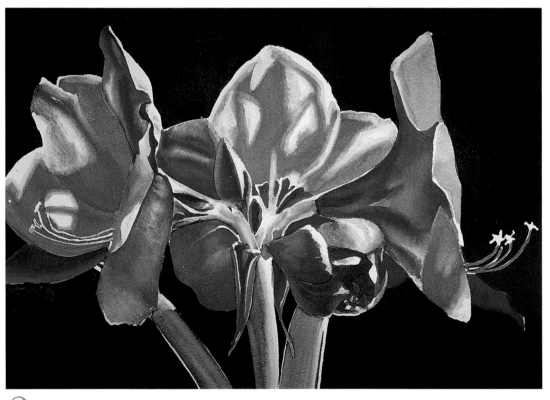

3 **BUILDING THE HOT REDS** | Use a fairly concentrated wet-in-wet wash of Quinacridone Red on the unopened buds and on the darker parts of each flower. Paint will probably seep into your light areas, so have a paper towel on hand to blot the color back. As you let this dry, step away from the painting and determine where the darkest values need to go.

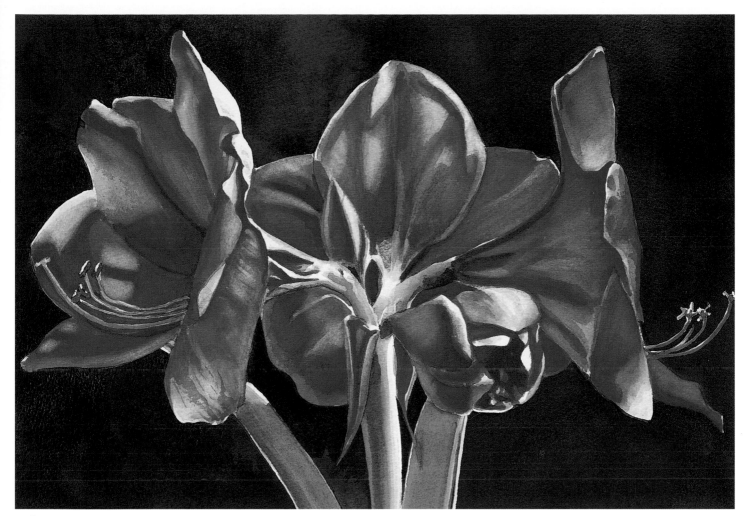

4 **ADD THE FINAL GLAZES** | To warm up the painting, add a concentrated wash of New Gamboge over the stems with your no. 8 round, being careful to leave a percentage of white paper where the extreme highlights exist on the stems. Use some of this concentrated New Gamboge to add a wash over the translucent parts of the petals as well. You can cover some of the areas previously protected with masking fluid, but again leave the extreme highlights white. Once the washes of New Gamboge are dry, you'll move on to using Cadmium Red Light. Using a very diluted Cadmium Red Light and your no. 8 round, paint a wet-on-dry wash over each entire flower. As a final step, mix Cadmium Red Light with a touch of Winsor Violet and apply it to the "necks" of the left and right flowers and to the inside of the partially opened front bud.

Red Amaryllis
13" x 19"
(33cm x 48cm)

Shorthaired Cat

THE UNDERPAINTING IS KEY to capturing the smoothness of a shorthaired cat. The foundation painting allows you to use loose wet-in-wet strokes to suggest the underlying muscles and shadows. In the end, drybrush strokes help accomplish the illusion of fur. The line along the outside of the cat's body remains defined by the darker colors in the background, pillow and chair, eliminating the need to paint individual hairs.

Capturing a cat in a calm pose like this isn't always easy. It helps to always have your camera on hand. It's even better to know which chair is the cat's favorite and to set up the camera ahead of time.

Materials

PAPER

Arches 300-lb. (640gsm) cold press

PAINT

Alizarin Crimson

Antwerp Blue

Burnt Sienna

Cobalt Blue

Hooker's Green

Permanent Rose

Quinacridone Gold

Sap Green

Winsor Violet

BRUSHES

Mop brush

Nos. 4, 6, 8 round

Scrubber Brush

OTHER MATERIALS

Masking fluid

Paper towels

Rubber cement pickup

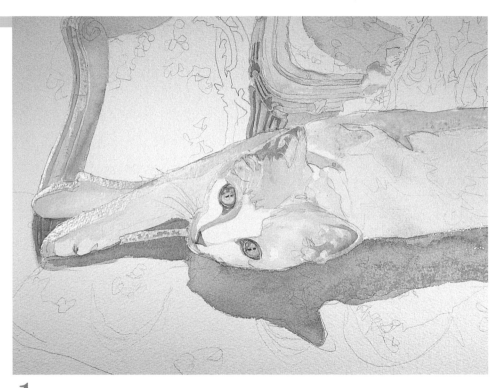

1 **LAY IN THE FIRST COLORS** | Mask out the top of the cat's body, including the whiskers on the right side and glints of light in both eyes. Wet the cat's body with clean water. In the areas where the muscles and shadows will be, use your no. 8 round to float in Alizarin Crimson, adding some inside both ears. While the paper is still wet, paint the cat's head and legs Cobalt Blue. Next, load your no. 4 round with Cobalt Blue and rim the eyes using the wet-on-dry method. Follow that with Winsor Violet. With your no. 6 round, paint the cat's irises Quinacridone Gold. Keep the color darker at the edges and lightest in the middle. When this is dry, use your no. 4 round to paint the pupils Winsor Violet. Paint the nose Permanent Rose.

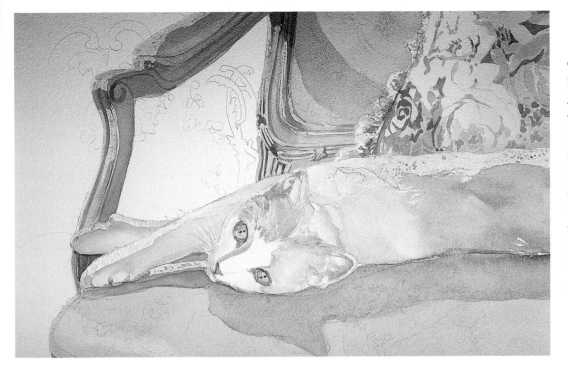

2 BUILD THE COLOR | Wet the cat's body with clear water again and load your no. 8 round with Winsor Violet. Apply the color to the cat's body with choppy, uneven strokes, letting the color bleed. While the paper is still wet, paint Burnt Sienna in the corresponding areas on the cat's fur. For the eyes, lay a graduated wash of Sap Green over the Quinacridone Gold from earlier. Blot up any excess paint with a paper towel.

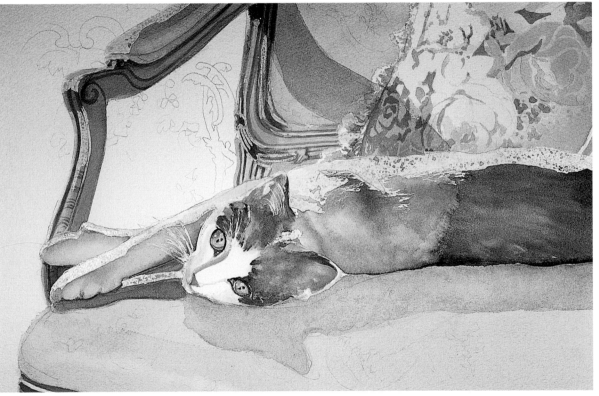

3 ESTABLISH THE DARKS | To create a neutral blue-gray, mix Antwerp Blue, Burnt Sienna, Alizarin Crimson, Hooker's Green and Winsor Violet together in the middle of your palette, keeping the mixture thicker than you normally would. If the color doesn't look right, you might need to add more Antwerp Blue. This will help bring back to the blue tone you're looking for in your gray. Wet the cat's body. Use your no. 6 round to paint uneven strokes of the blue-gray color. Paint the colored patch Burnt Sienna. With your no. 8 round, wet the back of the cat's head and the two forehead sections. Add the blue-gray to the back of the head and work your way forward until you are adding paint to dry paper. Finish the area around the ears and eyes with a wet-on-dry stroke (you don't want the blue-gray color bleeding in the white areas of the cat's face). Add another wash to the pupils, using the blue-gray this time.

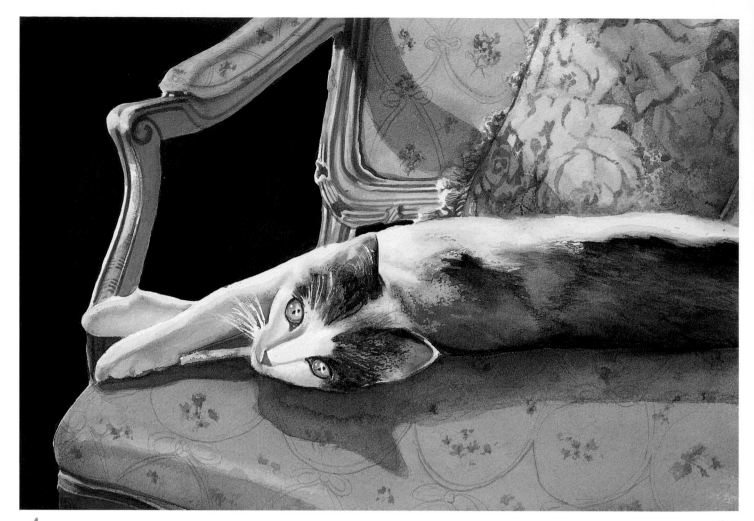

4 BLEND TO A FINISH | Remove the masking fluid using a rubber cement pickup. Soften any hard edges on the back and legs with a large, wet scrubber brush and a paper towel. This creates a soft transition from light to dark, which helps build form and the "feel" of fur. Mix more of the blue-gray color. Use the side of your no. 8 round to apply it to the back of the cat's neck and the two sections of the cat's forehead with an angled dragging motion.

Cat
13" x 19"
(33cm x 48cm)

Shells

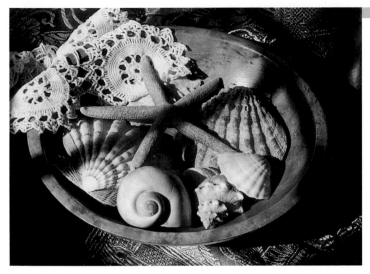

THIS COMPOSITION IS RICH WITH TEXTURE. The collection of shells varies in natural texture from rough and rippled to smooth and shiny. To establish the right tone, I started all of the shells with a Winsor Violet underpainting followed by layers of color. I drybrushed the rough details as a final step. For creating the form and texture of the smooth, shiny shell, I found multiple wet-in-wet glazes to be ideal.

Although the embroidered cloth is a man-made object, I've included it in order to suggest the ocean. The silk's shiny blue folds and the lace suggest a bubbly, frothy wave lapping on the shore.

Materials

PAPER
Arches 300-lb. (640gsm) cold press

PAINT
Alizarin Crimson
Burnt Sienna
Quinacridone Gold
Winsor Violet

BRUSHES
Mop brush
Nos. 4, 6, 8 round

OTHER MATERIALS
Masking fluid
Paper towels
Rubber cement pickup

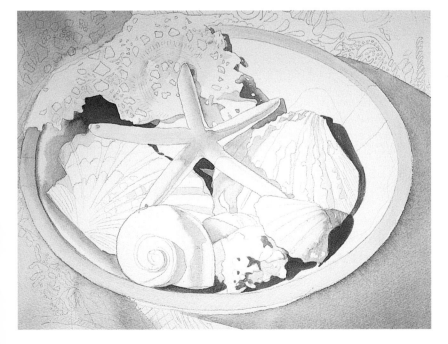

1 MONOCHROMATIC FOUNDATION | First, protect the whites and highlights with masking fluid. Then, with your no. 8 round, paint light washes of Winsor Violet where the shells cast their shadows. Create the large shadow cast by the bowl with a mop brush. Paint a wet-in-wet Winsor Violet wash on the nautilus-shaped shell in the lower part of the bowl. Wet the shell, then gently touch the loaded tip of your no. 8 round to the paper, following the gentle curve of the shell. Use this same technique on the starfish. Glaze a second wash of Winsor Violet (and even a third, if you dare!) to all the cast shadows.

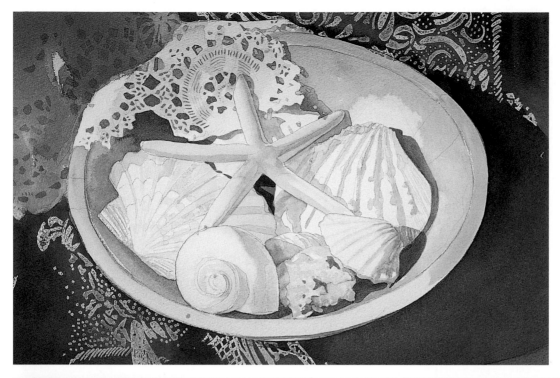

2 **ADD THE LOCAL COLOR** | The shells pick up the tones of the wooden bowl and reflect them back. To capture this, add graduated washes of Quinacridone Gold to the side of each shell and the starfish. Paint a wash of Quinacridone Gold in the crevices of the three rippled shells. You'll need to switch between your no. 6 and no. 8 rounds according to the size of each area.

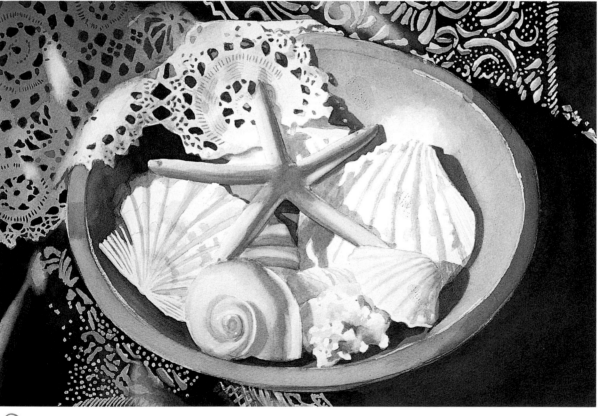

3 **ADD MORE COLOR** | Remove all masking fluid with a rubber cement pickup. For the striations and markings on the rippled shells, drybrush on a mixture of Quinacridone Gold and Burnt Sienna. This creates a base for the darker color later. Mix a little Quinacridone Gold with Alizarin Crimson. Paint wet-in-wet washes of this rosy color on the starfish and the nautilus-shaped shell.

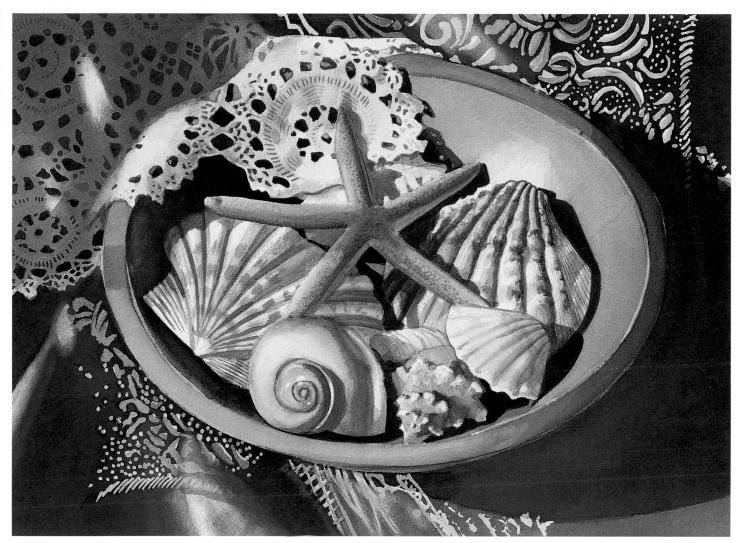

4 DRYBRUSH THE DETAILS | Outline the center of the nautilus shell and deepen the crevices of the rippled shells using Burnt Sienna and your no. 6 round. To create the bumpy texture on the large shell to the right, mix Burnt Sienna with Winsor Violet and use your no. 4 round to stipple. Start in the crevices and work your way to the left with uneven splotches of paint. Use Winsor Violet to give the same treatment to the starfish, but use smaller splotches. Start in the shadow and move out into the middle tones, but leave the highlights mostly untouched.

Shells
13" x 19"
(33cm x 48cm)

Longhaired Cat

THIS CAT IS A VERY SLEEPY CAT and loves the morning sun coming in through the east window in one of the bedrooms in my house. The sun was at a 45-degree angle and created good diagonal cast shadows from the cat's ears and front paw. The eyes of the cat are so sweet that I made them the focal point of the painting. I took extra care getting the eyes just right, adding extra masking fluid and deepening the shade of green to more closely match the background.

Longhaired cats have very soft, thin hair that tends to go in every direction. This is where masking fluid will be your best friend. The darker background and trunk frame the cat so that the white of the paper serves as most of the cat's color. The weathered old trunk and mottled background serve as a contrast to the cat's soft fur.

Materials

PAPER
Arches 300-lb. (640gsm) cold press

PAINT
Alizarin Crimson
Quinacridone Gold
Antwerp Blue
Burnt Sienna
Sap Green
Permanent Rose
Winsor Violet

BRUSHES
Mop brush
Nos.4, 6 round

OTHER MATERIALS
Masking fluid
Rubber cement pickup

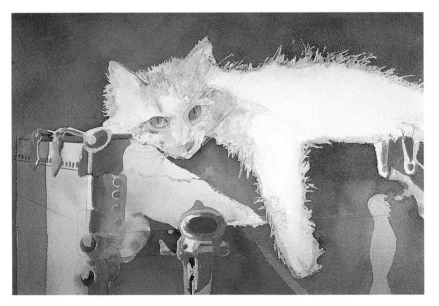

1 **LAY THE FOUNDATION** | Mask the whiskers and every outside edge of the cat's body with a small brush and long, thin strokes. Mask any highlights in the eyes as well. Rim the eyes with Winsor Violet. Paint a wash of Winsor Violet wet-in-wet on the top of the cat's head, leg, in the shadows on the face and body. Use your no. 4 round to paint a graduated wash of Quinacridone Gold in the eyes, following with a graduated wash of Sap Green. Keep the color lightest in the eye's center. The nose gets a wash of Permanent Rose.

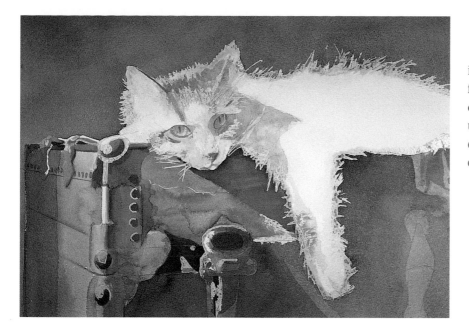

2 CREATE DEPTH | Add Alizarin Crimson as a wet-on-dry wash to the inside of the ears and to the right side of the face. Apply another wet-in-wet wash in the cast shadow on the cat's shoulder, this time using Alizarin Crimson. With a no. 6 round, drop Burnt Sienna into the area on the top of the head and round the right eye.

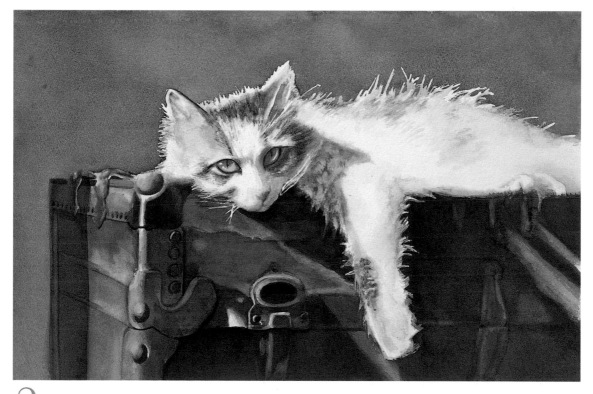

Ishta
13" x 20"
(33cm x 51cm)

3 DRYBRUSH TO A FINISH | Paint the patches of color on the cat's head, face and leg with a mixture of Burnt Sienna and Antwerp Blue. These two colors mix together to make a rich brown. Vary the value by adding more Antwerp Blue. Apply the color in wet-on-dry layers using a no. 4 round. Use quick, short strokes on the face and longer strokes near the ears and on the legs. Remove masking fluid with your rubber cement pickup.

Glass

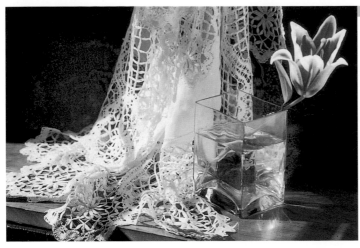

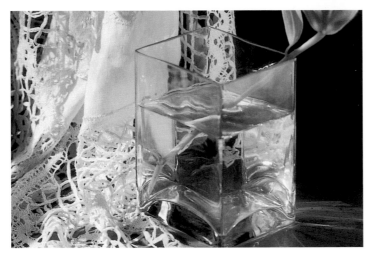

IN THIS COMPOSITION, I EMPHASIZED THE REFLECTION and refraction by positioning the vase so that two of its sides are visible. As a result, the stem bends into several disjointed, abstract shapes.

Painting glass requires careful observation of how light is reflected and refracted. Glass will absorb the colors of everything around it, so to make the glass more believable, you need to make the most of the surrounding colors. Incorporating the extremes of value will also help make the glass appear more realistic. A good way to achieve the slick texture of glass is to paint dark, closed shapes over lighter, more subtle areas of color.

Materials

PAPER
Arches 300-lb. (640gsm) cold press

PAINT
Alizarin Crimson
Antwerp Blue
Burnt Sienna
Cobalt Blue
Hooker's Green
Winsor Violet

BRUSHES
Mop brush
Nos. 4, 6 round

OTHER MATERIALS
Masking fluid
Paper towels
Rubber cement pickup

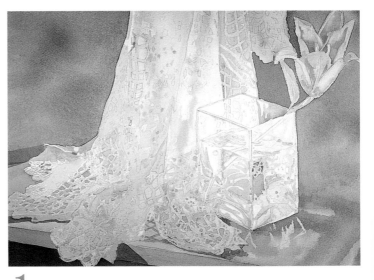

1 **MASK THE REFLECTIONS** | Mask out all reflections, including the lip of the vase. Spatter a few "dots" of masking fluid randomly to add a sparkle to the glass. When the masking fluid is dry, paint a wash of Burnt Sienna in the middle of the vase with your no. 6 round. To give the glass its depth, use your no. 6 round to paint the curved shapes of Cobalt Blue. Add a second wash of Cobalt Blue mixed with a little Antwerp Blue to the lower left of the vase. Use a Winsor Violet wash in the back right of the vase to suggest the background through the clear glass.

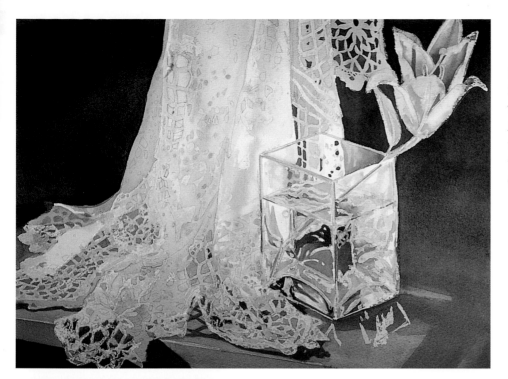

2 PAINT THE SURROUNDING COLORS | Use your no. 6 round to add more Cobalt Blue to the curved shapes in the bottom of the vase. Mix Burnt Sienna with Antwerp Blue to make a dark brown. Add this as a graduated wet-on-dry wash in the middle of the vase to reflect the color of the table. Paint the flower stem Hooker's Green with your no. 4 round.

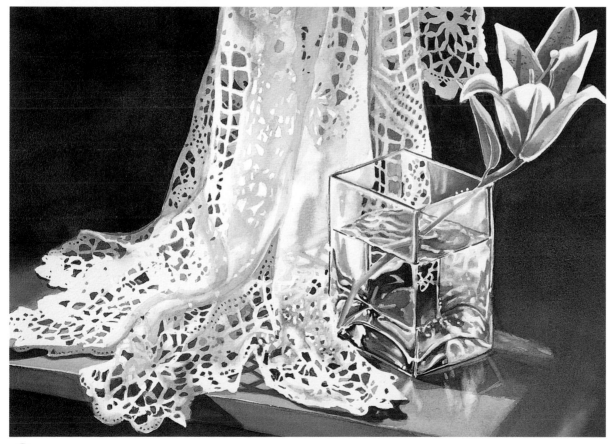

Glass
14" x 20"
(36cm x 51cm)

3 DEFINE THE SURFACE | Remove masking fluid from the rim of the vase. Mix Burnt Sienna, Alizarin Crimson and Antwerp Blue to make a grayish-black. Use this mixed color to draw a hard line with your no. 4 round on the left side of the rim underneath the white line that you just unmasked. This subtle shadow will serve to define the rim of the vase. Use this same color to emphasize the curved shapes of the glass in the bottom of the vase. You'll need to paint the lace that shows through the back of the glass above the waterline. Lighten the grayish black mix by adding water, then use this color to paint the holes in the lace. When all of the washes are completely dry, remove the masking fluid and clean up any jagged lines with paint. The key to realistic glass is hard, clean edges, so keep the lines crisp.

Hair in Sunlight

THE SKIRT THAT THE MODEL IS WEARING is actually a tablecloth. Since I only had one day with her, I loaded my backpack with different fabrics and clothes and took her to the botanical gardens. She was very cooperative, but she did look at me funny when I asked her to wear the tablecloth!

I originally chose this model because of the wonderful amber tones in her hair. The different layers of color proved to be an interesting challenge. I started with broad washes to establish form and finished by painting wet-on-dry in select areas. To keep hair from looking like a "helmet," it's a good idea to blend the hair and skin together.

Materials

PAPER

Arches 300-lb. (640gsm) cold press

PAINT

Alizarin Crimson

Antwerp Blue

Burnt Sienna

Cobalt Blue

Quinacridone Gold

Winsor Violet

BRUSHES

Mop brush

Nos. 6, 8 round

Scrubber brush

OTHER MATERIALS

Masking fluid

Paper towels

Rubber cement pickup

1 BEGIN WITH LOOSE WASHES |
Mask out the highlighted areas around the hairline, on the top and through the part. Mask out sections of hair and also a few single strands. Wet the hair and then lay down a loose Winsor Violet underpainting. On the hair falling on the left side of the model's face, paint a graduated wash of Winsor Violet using your no. 8 round and keeping the darker part of the wash towards her face. Follow this wash with Burnt Sienna. Mix Burnt Sienna with Antwerp Blue, then use this color and a no. 6 round to fill in the dark areas wet-on-dry on either side of her part.

Wet the hair again, then add light touches of Cobalt Blue. The cool color will recede, giving the hair depth. Let this dry completely before rewetting the hair. Coat the hair with Quinacridone Gold, avoiding the Cobalt Blue sections. Add Alizarin Crimson in random sections wet-in-wet with a no. 6 round. This warm color comes forward, adding even more dimension to the hair. Let everything dry before removing the masking fluid.

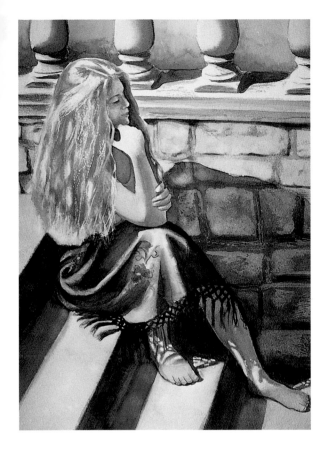

2 CREATE THE MIDDLE TONES | Use a scrubber
brush to soften the hard edges on top of the head and
in the hair. Leave the part itself as the only hard edge. Let
this dry, then lay a light wash of Burnt Sienna over the dark
areas. Add some Alizarin Crimson and Burnt Sienna to the
part in the hair, but keep it a value lighter than the skin on
the face. Wet the hair again using your no. 8 round. Add
wet-in-wet sections of Burnt Sienna in the receding waves.
Blot the light areas with a paper towel if the paint bleeds
too far.

3 ADD THE FINAL DETAILS | Mix Burnt
Sienna with Winsor Violet to make the darker
browns in the hair. Use this color and a no. 6 round to lay
a graduated wash in the profile area. Keep the darkest
area closest to the profile, lightening the wash as you
move away from the face. Painting wet-on-dry, add more
of this color on the top of the head and in the larger area
of cascading hair. Vary your strokes between large and
small and leave enough white to mimic the light hitting
individual waves of hair.

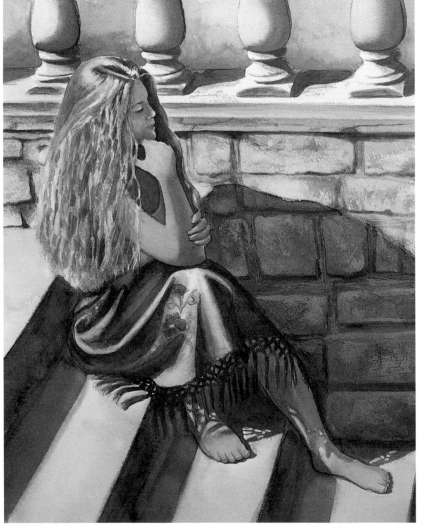

Concrete Planter

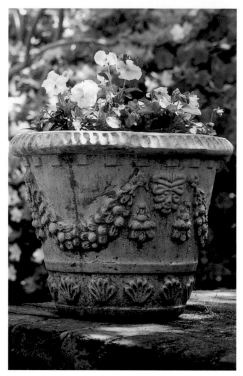

THIS CONCRETE PLANTER WAS SITTING in the corner of the botanical gardens underneath a crepe myrtle tree. Initially, the dappled light shed through the tree's small leaves caught my eye. Then I looked closer at the pairing of the rough, heavy planter with its delicate details and even more delicate pansies. It made a great study of extremes, I decided.

Concrete has a wonderful texture, despite being a hard, cold substance. To capture the texture—and keep it from being a static gray object in your painting—let the indirect light and color define it. Build warm and cool washes that reflect the colors of leaves and flowers in order to seat the planter in its surroundings. The final wet-on-dry details will age the planter and give it character.

Materials

PAPER
Arches 300-lb. (640gsm) cold press

PAINT
Alizarin Crimson
Antwerp Blue
Brunt Sienna
Cobalt Blue
Hooker's Green
Quinacridone Gold
Winsor Violet

BRUSHES
Mop brush
Nos. 6, 8 round

OTHER MATERIALS
Masking fluid
Paper towels
Rubber cement pickup

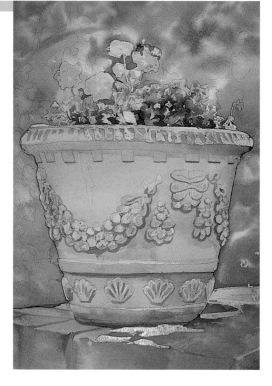

1 PAINT THE FIRST WASHES | The light source is coming from the left, so you want to make the right side shadowed. First, mask any highlights in the edges and rim of the planter. When this is dry, wet the planter with clear water. Then use your no. 8 round to lay Cobalt Blue wet-in-wet on the right side of the planter. The washes shouldn't extend past the middle of the planter. Reload your brush with Quinacridone Gold. Lay this color into the left side, also wet-in-wet, letting the color meet the Cobalt Blue in the middle. Let this dry. Rewet the area, then use your mop brush to drop Winsor Violet on the right side, making sure the color extends to the top and bottom lips of the planter. Use your no. 6 round to apply Alizarin Crimson wet-on-dry to the underside of any details in relief on the planter.

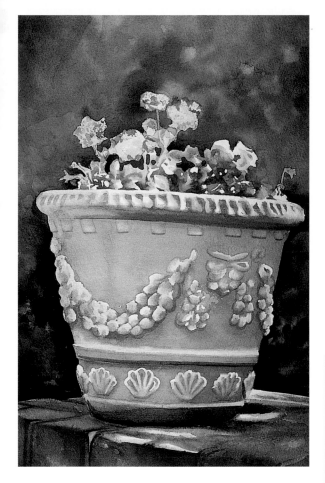

2 DEEPEN THE VALUES | Mix a neutral gray by combining Antwerp Blue, Burnt Sienna, Alizarin Crimson and Hooker's Green. Add enough water to make a light gray. Wet the planter with clear water and use the mop brush to paint a wash of neutral gray over the whole planter. Allow this to dry, then, using a less diluted version of the neutral gray, define the details a little more. Use your no. 8 round to add this darker value along the bottom and under the lip of the planter. Once this is dry, remove the masking fluid.

3 ADD THE TEXTURE | Mix more of the neutral gray from Antwerp Blue, Burnt Sienna, Alizarin Crimson and Hooker's Green, but use less water in order to make the color more concentrated, almost black. Dip your no. 8 round in this color and blot on a paper towel. Drag the side of the brush along the bottoms of the garlands and elsewhere to create the aging and water stains.

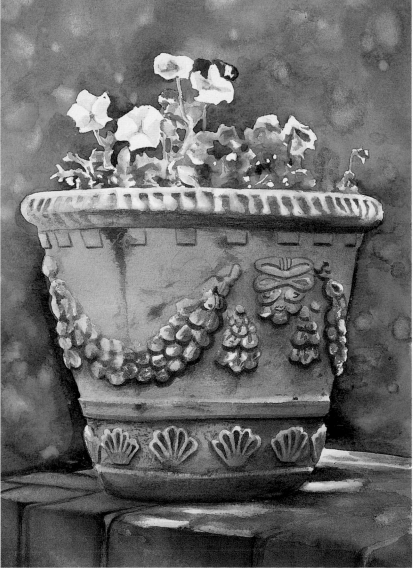

Pansy Pot II
11" x 16" (28cm x 41cm)

Patterned Fabric

I **PURPOSELY ROLLED** this heavy cotton tablecloth into a ball and tossed it in a closet for a few days to create pronounced wrinkles. The color and patterns of the cloth shift subtly with the wrinkles. To create this effect, I started with the local color and then added washes to the darker part of the wrinkle or fold. At the end, I used an unusual trick to pull the fabric together: I used the fine-tip end of a Prismacolor marker to mimic the outlines in the actual fabric. I used Dark Umber rather than Black because the brown ink is dark enough, but far more subtle.

Materials

PAPER
Arches 300-lb. (640gsm) cold press

PAINT
Cobalt Blue
New Gamboge
Quinacridone Gold
Quinacridone Red
Sap Green
Ultramarine Blue

BRUSHES
Nos. 6, 8 round
Scrubber brush

OTHER MATERIALS
Berol Prismacolor marker #PM-61
 (Dark Umber)
Masking fluid
Paper towels
Rubber cement pickup

1 APPLY THE LOCAL COLOR | Mask out any white areas in the fabric's pattern. Apply New Gamboge to all the yellow areas with your no. 8 round, painting with an even stroke. Use Cobalt Blue for the blue parts of the cloth. Mix Cobalt Blue with Sap Green to make a pastel green for the corresponding greens in the tablecloth. You can use your no. 8 round for all these colors.

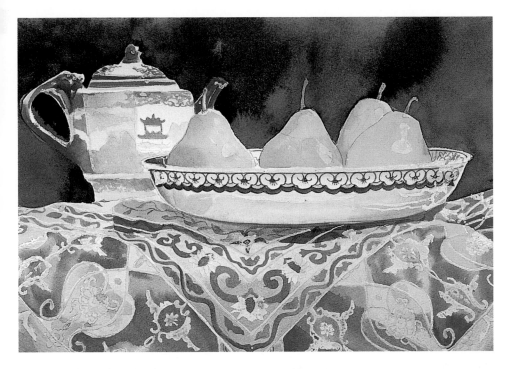

2 ADD SHADOWS | Where the cloth is receding or in shadow, you want to paint it a darker value. So paint the folds and wrinkles using a graduated wash, letting the wash lighten as it moves away from the shadows. You can use either your no. 6 or no. 8 round for this step. You'll approach each color on the cloth the same way. For the yellow areas, use Quinacridone Gold. For the blue, use Ultramarine Blue. For the pastel green, use a more concentrated wash of the Cobalt Blue and Sap Green mix from the previous step. Allow these to dry, then repeat. Create the cast shadow of the bowl with two graduated washes of Cobalt Blue; the color should be a little darker at the base of the bowl. Remove the masking fluid with a rubber cement pickup.

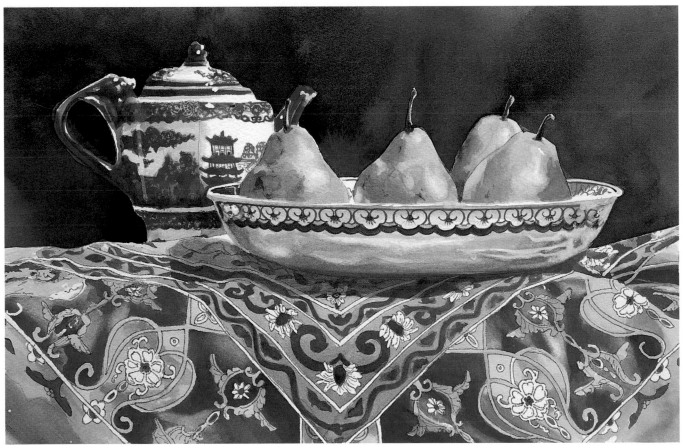

3 FINISH WITH THE DETAILS | Soften the transitions from dark to light with a wet scrubber brush for scrubbing and a paper towel for blotting. Once this is dry, paint the center of the flowers in the fabric Quinacridone Red. Use the Sap Green and Cobalt Blue mixture to add the details that were previously under masking fluid.

Finally, using the fine-tip end of the Dark Umber marker, outline the fabric's pattern and the little details. This must be the last step because you can't paint over the marker lines. This step pulls the whole painting together and adds an illustrative feel to the finished product.

Patterns
11" x 17"
(28cm x 43cm)

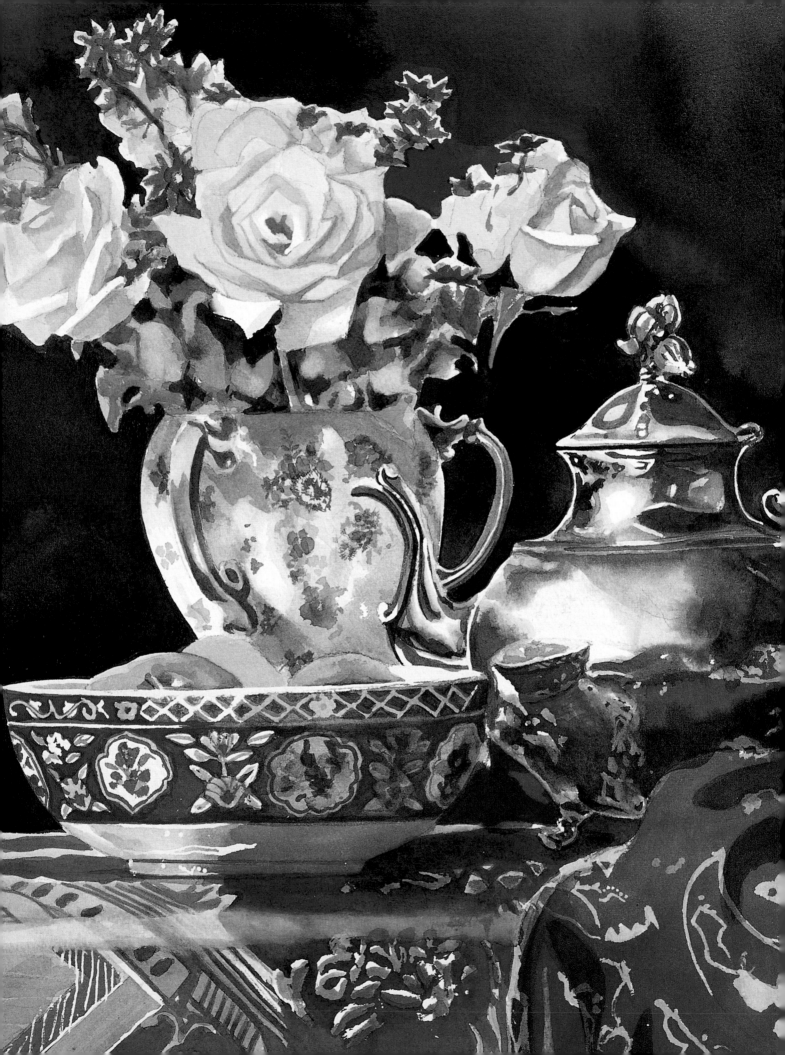

The Big Picture

In this final chapter, I'll guide you step by step through three different paintings. You'll begin to learn what to expect your paintings to look like at the different stages of development. Patience and perseverance are key to tackling complex paintings such as these, so don't expect to complete them in a day. These three paintings took me a total of three weeks to complete. I paint about five hours a day on good days. I tell you this because it is one of the questions I'm asked most and because I don't want you to become discouraged after only a day or two of trying these new techniques. The more you paint, the better you'll get!

Pattern Study
17" x 22" (43cm x 56cm)

Putting It All Together

THIS PAINTING COMBINES SEVERAL TEXTURES and patterns, making it a luxurious feast for the viewer. It can be accomplished by using a limited palette of only ten colors.

Since there is so much detail in this painting, I took many pictures of each item close-up so that I could properly render the shadows and reflections. I decided to make the background simple and darkly layered to give the viewer's eye relief from the detail in the rest of the painting and to bring the light items forward in space.

Materials

PAPER
Arches 300-lb. (640gsm) cold press

PAINT
Antwerp Blue
Alizarin Crimson
Burnt Sienna
Cadmium Red Medium
Cobalt Blue
Hooker's Green
Quinacridone Gold
Quinacridone Red
Transparent Yellow
Winsor Violet

BRUSHES
Mop brushes (3)
nos. 4, 6, 8 round
Scrubber brush

OTHER MATERIALS
Masking fluid
Paper towels
Rubber cement pickup

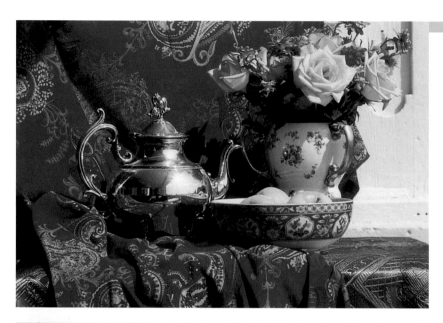

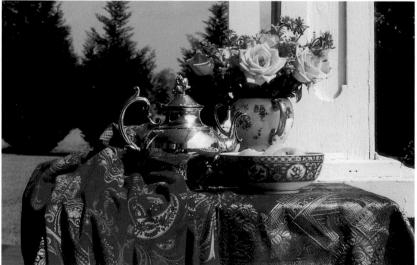

GOOD REFERENCE PHOTOS
These are only two reference photos of the twelve I used for this painting. I set up my photo shoot outside (on a day with no wind) in order to have strong lighting. The final painting is a combination of all of the photos. The long shots help with the compositional decisions and close-ups help in the drawing process where details are concerned.

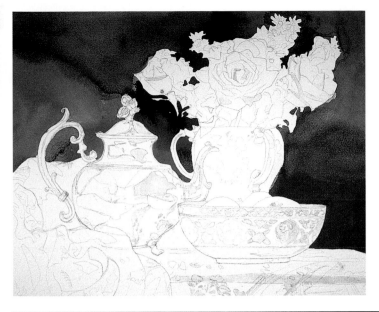

1 START WITH THE BACKGROUND | Once your drawing

is finished, use masking fluid and an old brush to mask out highlights in the painting. Also mask out the details in the cloth so that you can paint the background of the cloth freely and evenly.

Antwerp Blue, Alizarin Crimson and Burnt Sienna will be your background colors. Mix enough of each to get you through this first layer. Use three different mop brushes, one for each color. Make sure that your work area is completely flat. Begin at the edge of the painting with one of the colors and the mop brush, dragging away from the edge. Pick up the next color and begin where the last color left off. Continue to switch colors and move swiftly across the painting. Use your no. 8 round to gently pull color around delicate areas close to objects. Use a smaller set of three brushes when you paint the smaller, closed smaller areas, like inside the handles of the vase and silver teapot. Keep the painting completely flat while it dries.

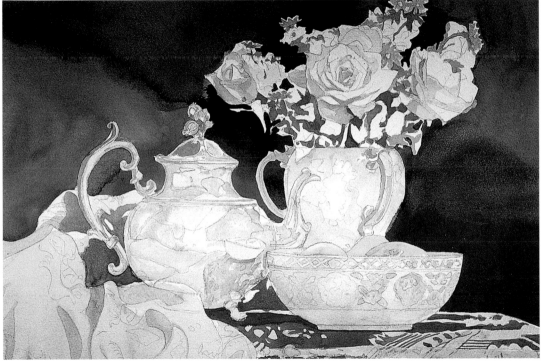

2 ADD THE BASE COLORS | To build the smooth texture of the teapot,

vase and bowl, apply washes of Cobalt Blue with your no. 6 round. Once this is dry, add wet-in-wet washes of Alizarin Crimson to areas on these objects that reflect the red cloth.

To begin defining the folds and shadows of the red cloth, paint wet-on-dry washes of Winsor Violet. Let this dry, then add a second coat to darken the value.

Use your mop brush to apply Antwerp Blue to the blue cloth. The stems and leaves of the flowers also get an Antwerp Blue underpainting. Apply a second, more concentrated coat in the darker areas after the first coat dries.

On your palette, mix Quinacridone Gold with Burnt Sienna. Apply this new color wet-on-dry to the middle and darkest areas of each yellow rose with your no. 6 round.

Keep Your Subjects on Hand

Even if you take reference photos of your still life arrangement, it's a good idea to keep the objects around while you paint. Photos don't give all of the details that you might want to add. Having an object on hand is great for quick examination of patterns and colors.

| 111

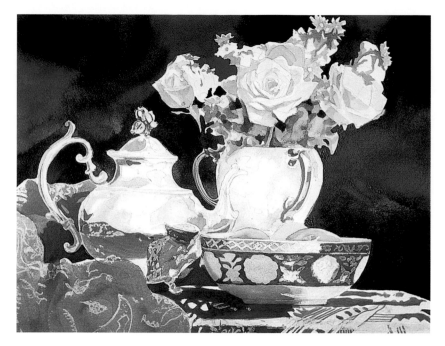

3 STRENGTHEN THE COLORS | Use the colors from the first application of the background, but this time change the order. You want to avoid layering the same colors on top of one another. Let everything dry flat.

Use your no. 8 round to add graduated washes of Transparent Yellow to each rose's petals. Begin at the center and pull outward to create a soft texture.

Paint the vase handles wet-on-dry using Quinacridone Gold mixed with a touch of Burnt Sienna.

Wet the patch of leaves and stems underneath the roses with clear water. Paint the shadow areas with Burnt Sienna and Hooker's Green. Wet the cloth on the left with clean water. Use Alizarin Crimson to paint the cloth.

Wet the left side of the bowl and add Antwerp Blue. Once the other washes are laid over it, the Antwerp Blue will make the left side of the bowl look shadowed. Let this dry. Mix Quinacridone Red, Cadmium Red Medium and Quinacridone Gold to create an orange-red for the local color in the bowl's decorative band. Apply the color wet-on-dry with your no. 8 round.

Add more Alizarin Crimson, Antwerp Blue and Cobalt Blue in separate wet-on-dry washes on the silver teapot in the corresponding reflections.

4 BUILD TO A FINISH | Wet the red cloth again and this time use your mop brush to add a layer of Alizarin Crimson mixed with Quinacridone Red. Allow this to dry. Mix Quinacridone Red with Cadmium Red Medium and repeat the technique, but only adding this color to the darker parts of the cloth and blotting the lighter areas with a paper towel. To add shadows, drybrush Burnt Sienna to the vase handles with a no. 6 round.

Mix a neutral gray for the silver (see page 60). Wet the teapot with the mop brush, then switch to your no. 8 round to apply the paint. For the first wash of gray, add a lot of water to a section of the mixture. Save the remainder for the drybrush work later on.

Add another layer of Transparent Yellow to the roses in graduated washes using your no. 6 round.

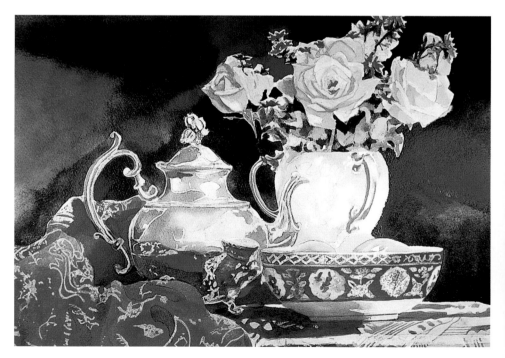

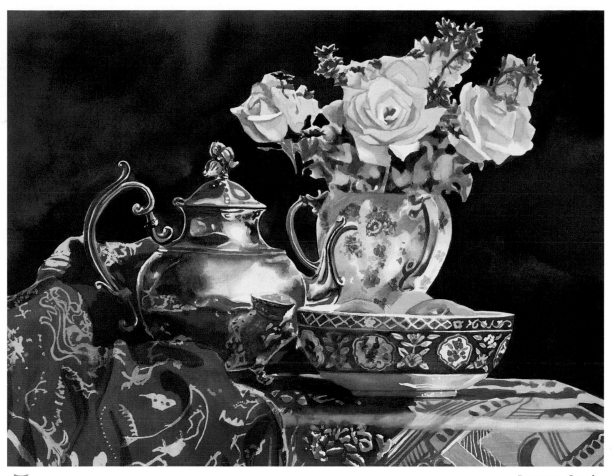

5 **REMOVE THE MASKING FLUID** | After each area of your painting is completely dry, gently remove the masking fluid with your rubber cement pickup. You will notice choppy edges where objects meet the background. To fix this, create a thick mixture of the background colors. Use your no. 4 round to "outline" the choppy objects, cleaning up their edges. As long as you keep the line the width of the brush, nobody will ever be able to tell!

Grab a wet scrubber brush and scrub any of the masking edges that you want to soften. Detail the bowl and the vase with small, drybrush strokes. This is where having the actual objects nearby will help you decipher the details that the photos cannot.

Add Quinacridone Gold in the pattern on the red cloth. Add Burnt Sienna wherever the pattern falls in a shadow.

With your no. 6 round, drybrush the details into the silver with the remainder of the neutral gray. Switch to other colors as you see them reflected in the silver. The more colors that you use in the silver in addition to the neutral gray, the more realistic the texture will be.

A Painting's Progress

The best way to gauge a painting's progress is to set it up on an easel or tape it to a wall and then back a good distance away from it. Sometimes you get a better perspective by changing *your* perspective!

Nourished to Bloom

THIS TEAPOT HAS A SPECIAL HISTORY in my family. My younger sister and I used it when we were children to have our "tea" parties (we used water as tea). Mom also used this pot to serve real green tea with take-out food to make the meal seem like a special event. The two blooming amaryllis flowers represent my sister and myself having been "watered" and nourished to bloom by the experiences with the teapot and with each other. When you select things to paint that are meaningful to you, you'll produce a better painting.

Materials

PAPER
Arches 300-lb. (640gsm) cold press

PAINT
Alizarin Crimson
Antwerp Blue
Burnt Sienna
Cadmium Red Medium
Hooker's Green
Quinacridone Gold
Quinacridone Red
Transparent Yellow
Ultramarine Blue
Winsor Violet

BRUSHES
Mop brushes (3)
Nos. 4, 6, 8 round
Scrubber brush

OTHER MATERIALS
Masking fluid
Paper towels
Rubber cement pickup

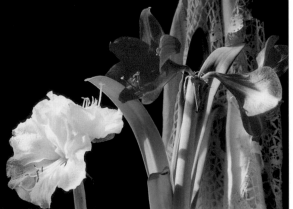

THE PRIME HOUR
The wide shot gives an idea of the composition and where highlight and deep shadow areas should fall. These photos were done inside next to a window that casts a glorious shaft of light at the right time of day. I set up the general composition early in the morning and waited for the sun so that I was not messing with the composition during the prime hour.

PERISHABLE OBJECTS
It took about a roll of film to come up with these two final reference photos. The close-up of the two flowers shows a great deal of detail, and its darker exposure reveals more of the individual petals. This type of flower only blooms for a short time, so it was essential to get as many accurate photos as I could since I wouldn't have the real thing for long.

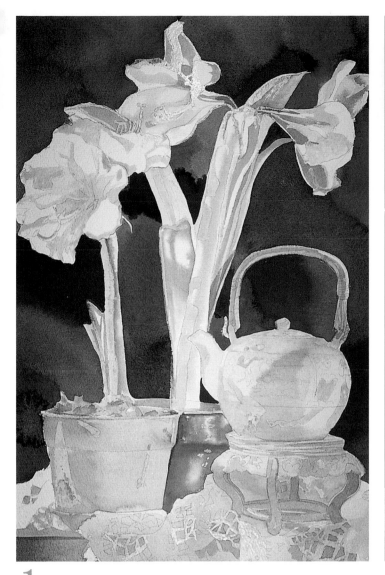

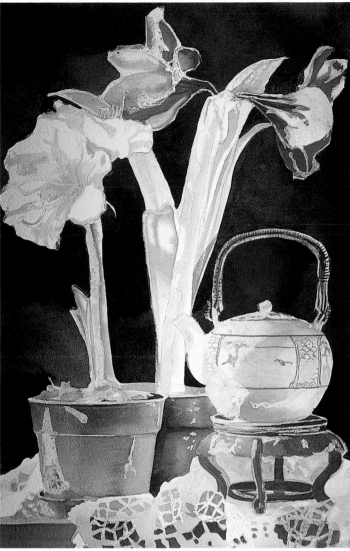

1 ADD COLOR TO EVERYTHING | Mask out the highlights. Make pools of Antwerp Blue, Burnt Sienna and Alizarin Crimson in the large wells in your palette. Use three mop brushes (one for each color) to apply the paint, dragging patches across the large areas of the painting. For the smaller areas, such as in between the broad leaves, use three different no. 8 rounds (one for each color). Let the background dry flat.

Wet the broad leaves and stems with clear water and use your no. 8 round to add stripes of Antwerp Blue. Apply a wet-in-wet wash of Antwerp Blue to the pot in the back of the painting and a Quinacridone Gold wash to the front pot. Add a light wash of Quinacridone Gold to the teapot's bamboo handle. Wet the teapot and float in Antwerp Blue starting on the heavy shadow and working out.

Use Winsor Violet to add color to the wooden pedestal, the lace and the shadows in the red flower. Drybrush Transparent Yellow on the white flower with your no. 6 round.

2 BUILD THE TEXTURES | Wet the front flowerpot and paint a three-inch (8cm) stripe of Antwerp Blue down the middle with your no. 8 round. This begins to build the curved and smooth texture of the plastic pot.

On the teapot, add another wet-in-wet application of Antwerp Blue. Wait for this application to dry, then rewet the teapot. Add Alizarin Crimson to the teapot and drop in some Burnt Sienna at the bottom to reflect the pedestal color. Use Burnt Sienna mixed with Antwerp Blue to add some drybrush detail to the bamboo handle. When the teapot body is dry, use some Antwerp Blue mixed with a little Ultramarine Blue to begin drawing the illustrated details with your no. 4 round.

Add Quinacridone Red mixed with Cadmium Red Medium to the flowers. Apply the mixture with your no. 8 round in graduated washes.

Add a drybrush wash of Burnt Sienna on the wooden pedestal. Mix Burnt Sienna with Antwerp Blue and paint the lace holes.

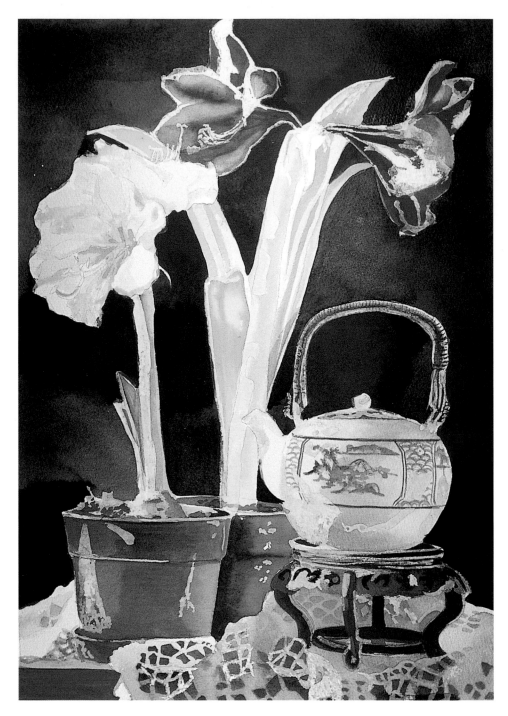

3 STRENGTHEN THE COLORS AND TEXTURES | Use your no. 8 round to apply Transparent Yellow over all of the broad leaves and stems and add more to the center of the white flower.

With your no. 6 round, add another wash of Quinacridone Red and Cadmium Red Medium to the red flowers, keeping this wash dedicated to the darker shadows of the flowers.

Mix Antwerp Blue with Hooker's Green to get the dark color of the plastic pot in the background. Add a wash of Burnt Sienna to the foreground flowerpot with your no. 8 round.

Mix Burnt Sienna and Antwerp Blue to get the color for the wood pedestal. Apply this color in a graduated wash with your no. 6 round, keeping the wash lightest where the highlight will be. Use your no. 4 round and a more concentrated version of this dark brown for the cutout details in the pedestal.

Continue detailing the teapot. Using Antwerp Blue mixed with a little Ultramarine Blue, paint the patterns wet-on-dry with your no. 4 round.

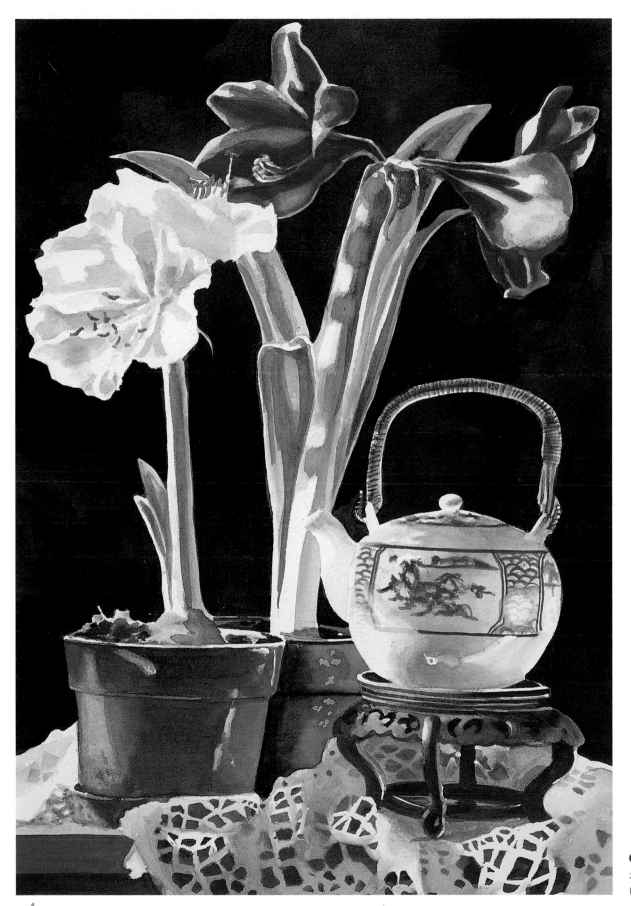

Chinese Tea
20" x 14"
(51cm x 36cm)

4 **COMPLETE THE PAINTING** | Remove the masking fluid. Soften the unnecessarily hard edges. Use a wet scrubber brush to scrub the edges and a paper towel to blot. Clean up any rough edges by using the remainder of your background colors and your no. 4 round.

Finally, add some Hooker's Green to the broad stems and leaves.

Antique Lace

THE LACE IS A HANDMADE antique round tablecloth that has more holes than fabric. I like it as a subject because it shows the table underneath and creates delicate reflections in the silver.

This painting has a strong motif of repeating arches and oblong curves. The items have no relation to each other in real life, but the similarity in the shapes of each item creates a pleasing and cohesive composition. The lace drapes in a half-circle that imitates the dip of the gravy boat whose curved handle closely resembles the swirling details on the wooden table. The limes were added for a touch of vibrant color, but their oblong shapes further emphasized the curves of the painting.

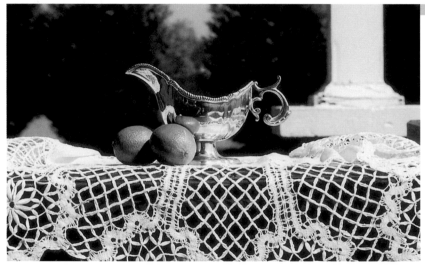

FOCUS ON DETAILS
The close-up will help you in drawing particular reflections and details in the silver and on the limes.

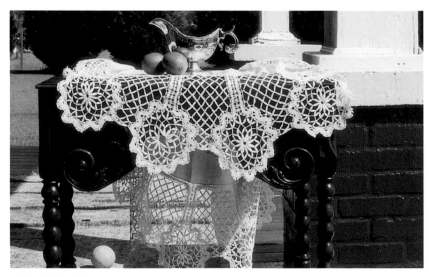

THE COMPOSITION
This photo gives you the layout for the complete painting. I already knew when I began the photo shoot that I was going to add my own background, so it was okay to have my dog's ball be in the shot!

Materials

PAPER
Arches 300-lb. (640gsm) cold press

PAINT
Alizarin Crimson
Antwerp Blue
Burnt Sienna
Cobalt Blue
Hooker's Green
Quinacridone Gold
Sap Green
Transparent Yellow
Winsor Violet

BRUSHES
Scrubber brush
Mop brushes (3)
Nos. 4, 6, 8 round

OTHER MATERIALS
Hair dryer
Masking fluid
Paper towels
Rubber cement pickup

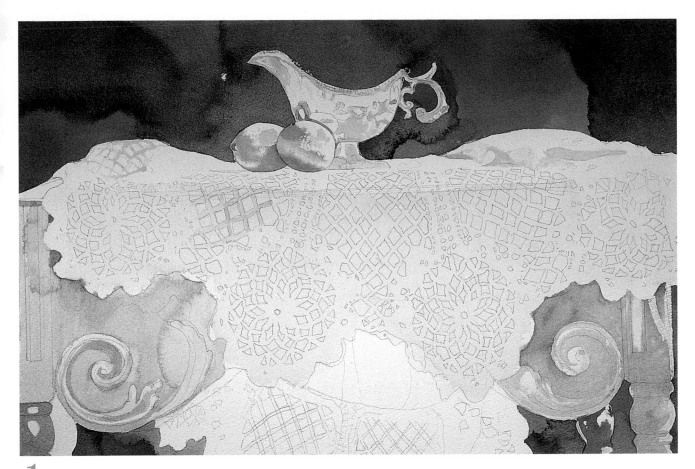

1 **PAINT THE BACKGROUND AND BASE COLORS** | Before anything else, mask the high-
lighted areas on the table, silver gravy boat and limes. When the masking fluid is dry, paint the
background.

Burnt Sienna, Hooker's Green and Antwerp Blue will make up the rich background for this painting.
Use one mop brush for each color. Start at the edge of the painting and work your way across, alternating
colors about every three inches (8cm). Think of it like mopping a floor. Paint the area in the handle of
the silver gravy boat with smaller brushes. Let the painting dry flat.

Use your mop brush to apply a light Quinacridone Gold wet-on-dry wash to the portion of the lace
that falls over the table. The lace covering the table top should remain white using the white of the
paper.

Wet one of the limes with your no. 8 round and clear water. Use your no. 6 round to add Antwerp
Blue, starting in the darkest shadow and pulling out. Dry this with a hair dryer and then repeat the step
with the other lime. Add Antwerp Blue to the corresponding reflections of the limes in the silver.

Begin the base colors in the wood by applying Winsor Violet in a wet-on-dry wash with your no. 8
round. Add a second coat to the hard shadows.

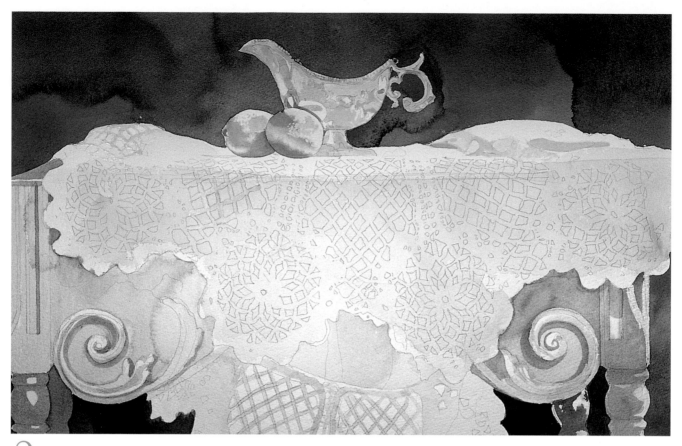

2 **BUILD UP THE COLOR** I Wet the front piece of lace with a clean mop brush and add a light wash of Burnt Sienna. While this wash is still wet, use your no. 8 round to add Alizarin Crimson in the far right section of lace and wherever you want to indicate a slight fold or bend. Let this dry.

Wet the piece of lace underneath the table and add Cobalt Blue in a wet-in-wet wash. While this is still wet, use your no. 8 round to add some Winsor Violet to the Cobalt Blue wash. (I left the holes white, but that wasn't necessary; you can paint right over the holes since you'll be filling them in later.)

Wet the gravy boat with clean water then use your no. 6 round to paint it Cobalt Blue. This will give a good base color for the next layers.

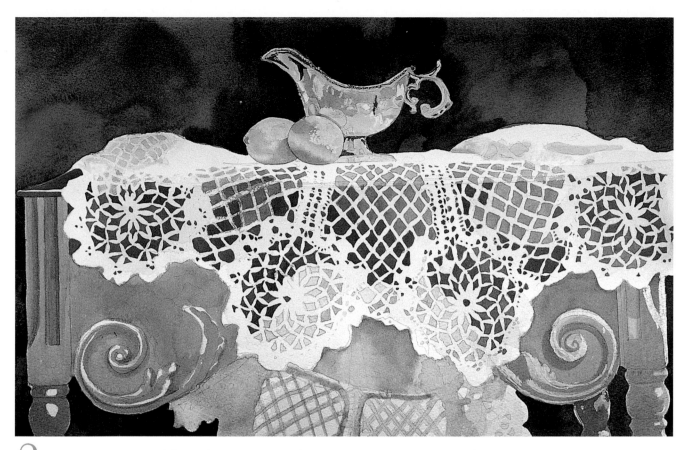

3 ADD THE LAYERS | Apply the second layer of the background next. Use the same three colors as in the first layer, but apply them in a different order so that, for example, Burnt Sienna goes over Antwerp Blue to create a deep brown. Let this dry flat.

Use your no. 6 round to paint a graduated wash of Transparent Yellow to the limes and their corresponding reflections in the silver.

Use your no. 8 round to apply a wet-on-dry wash of Quinacridone Gold to the wood.

On the cloth behind the table, add more Cobalt Blue in a wet-in-wet wash. Once this is dry, paint a graduated wash at the top of this section of lace using Burnt Sienna. This reflects the color of the table and helps to visually pull the main piece of lace forward.

Wet the falling lace with clean water again, then use your mop brush to paint it with a wash of Alizarin Crimson and Quinacridone Gold. This will give the cloth a little more volume and weight.

Use Burnt Sienna mixed with Quinacridone Gold to fill in the lace holes. This is just the first layer, so do not try to make the holes their darkest in one application. Add water to your palette mixture to make a lighter color for the lace holes on the top of the table. Look carefully at your reference photo to see where the table ends behind the lace. Use a Winsor Violet and Cobalt Blue mixture for these holes.

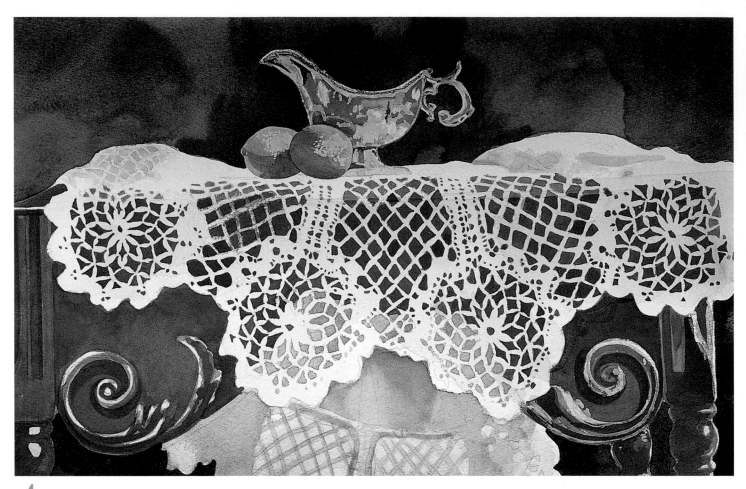

4 **DEEPEN AND DARKEN** | The neutral gray for the silver is comprised of Antwerp Blue, Alizarin Crimson, Burnt Sienna and Hooker's Green. You can change the value of this color by adding water. Make the color thick in the middle of your palette, then pull some of it to the side and add water for the first layer of the silver. Wet the silver with clean water and use your no. 8 round to add the neutral gray (blot the brush on a paper towel first) to the whole gravy boat. When this is dry, go back to the thick mixture and begin a small graduated wash right behind the limes. Look at your reference photo and begin to add hard-edged, wet-on-dry reflections in the silver.

Paint the limes with a wash of Sap Green using your no. 6 round. Once this dries, you can determine if you want to add more contrast by painting more Antwerp Blue in the shadow areas of the limes. Don't forget to add washes of these colors to the reflection of the limes.

Make a generous pool of Burnt Sienna in your palette well and use your no. 8 round to paint the wood of the table with this color.

Add some Antwerp Blue to Burnt Sienna to make a rich brown. Use your no. 6 round to add the second layer of color in the lace holes.

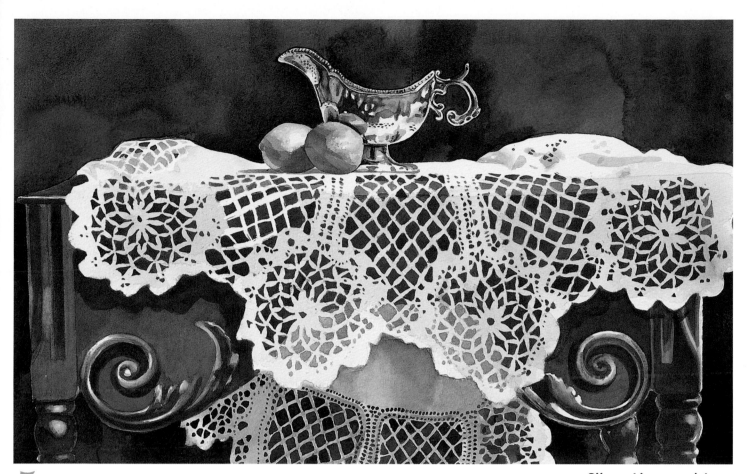

ADD THE FINAL DETAILS

5 **ADD THE FINAL DETAILS** | Remove the masking fluid. Smooth out any rough edges with a wet scrubber brush, blotting them dry with a paper towel.

Mix together the colors from the background and use this in the lace holes in the cloth under the table.

Drybrush details to the silver with a no. 4 round and more of the neutral gray mixture. Also use some Burnt Sienna to reflect lace holes in the silver.

Mix Burnt Sienna with some Antwerp Blue to make a dark brown. Drybrush details and hard shadows to the table with your no. 8 round. Be sure to keep the highlight areas white to keep the shiny texture of the wood.

Anchor the limes to the tables with shadows, using Cobalt Blue mixed with a touch of Winsor Violet. Anchor the gravy boat, too, using a thin line of the neutral gray mix from earlier.

Emphasize the reflective quality of the silver by adding washes of the surrounding colors, from the limes to the shadows.

Silver, Limes and Lace
13" x 21" (33cm x 53cm)

| 123

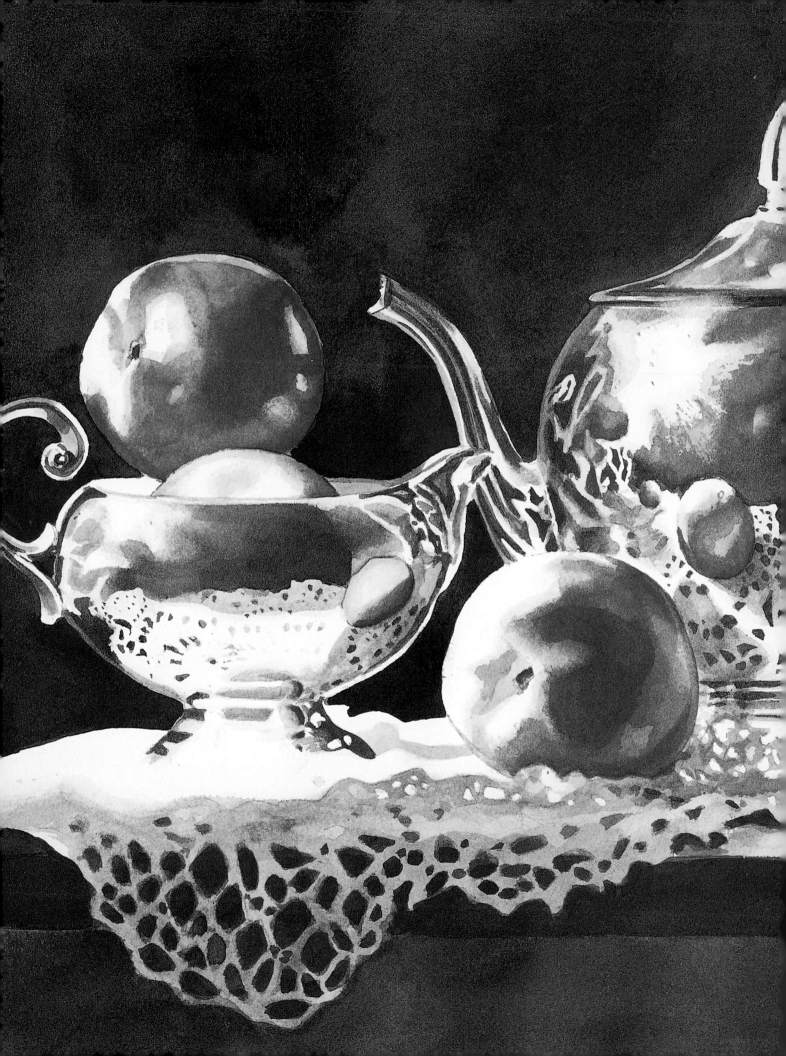

Conclusion

Thank you for letting me share some of my watercolor painting techniques with you. I hope your mind has been opened to a new way of painting with watercolor. My aim is for this book to make its way into your permanent library and for it to have dog-eared pages years from now because of all of the times you've referenced it.

That is what all of my North Light books look like!

Index

A

Antique lace
 background, painting, 119
 base colors, painting, 119
 colors, building, 120
 deepening/darkening, 122
 demonstration, 118–123
 details, addition, 123
 layers, addition, 121
Apple Tea, 59
Apples
 demonstration, 84–86
Artist's tape, 17
Ashes in a '53 Cadillac, 26

B

Background
 demonstration, 66–68
 addition, 63
 initiation, 111
 painting. *See* Antique lace
Backlighting, 54–55
Balance, creation, 24
Base, building, 80
Base colors
 addition, 111
 painting. *See* Antique lace
Black foam board, usage, 30
Blue and Yellow, 57
Blue Vase, 10–11
Brushes, 15. *See also* Mop brushes
 holding/movement, 15
 shedding, 15

C

Callas, Tulips and Oranges, 50–51
Cast shadows, 56
 painting, 41
Cat, 94
Center of interest, 27
Chinese Tea, 116, 117
Chrysanthemum Grace, 60
Cloth, usage, 21
Cold-pressed paper, 11, 16
Colors
 addition, 69. *See also* Base colors; Local color; Shells; Teapot
 building, 62. *See also* Antique lace; Porcelain teacup; Shorthaired cat
 contrast. *See* Warm colors
 deepening/darkening, 67
 determination. *See* Shadows
 dots, 43
 drybrushing, 55
 exploitation, 39
 harmonization, 59
 light layers, usage, 72
 strengthening, 112. *See also* Teapot theory, 59
Concrete planter

demonstration, 104–105
Cool colors, contrast. *See* Warm colors
Cool gray, warm gray (contrast), 60
Corners, consideration, 21
Crystal Vase, 68
Cup for Me, The, 83

D

Darks
 establishing. *See* Shorthaired cat
 retreating, 40
 sculpting, 55
Depth
 addition, 25
 creation. *See* Longhaired cat
Detail
 addition, 63. *See also* Antique lace; Hair in sunlight; Wet-on-dry technique
 drybrushing. *See* Shells
 finishing. *See* Patterned fabric
 technique. *See* Wet-on-dry detail technique
Diana, 22
Drawing, masking fluid (usage), 47
Drawing pencils, usage, 17
Drybrushing, 35. *See also* Colors; Layered drybrushing; Longhaired cat; Shells

E

Embroidered silk
 demonstration, 72–74
Everlasting Beauty, 64–65, 74
Eyes, rest, 23

F

Flat washes, 34
Foam board, usage. *See* Black foam board; White foam board
Folds, creation, 70
Form shadow, 56
Format, variation, 28
Found images, composition, 30
Foundation. *See* Shells
 laying, 77. *See also* Longhaired cat
Four Pears, 78, 79
Fruits and Lace, 70, 71

G

Garden Bench, 20
Garden views, 20
Geraniums, 8–9
Glass
 demonstration, 100–101
Glass, 100, 101
Glazes
 addition. *See* Porcelain teacup
 usage, 49. *See also* Colors; Embroidered silk
Glazing, 40–42
 yellow, usage. *See* Apples
Gloxinia, 47
Golden Delicious, 86

Graduated washes, 34
Graduation Cup, 29
Gray
 components. *See* Neutral gray
 contrast. *See* Cool gray
Greens, variation, 37

H

Hair dryer, 17
Hair in sunlight
 demonstration, 102–103
Halo, masking, 54
Hard shadows, 56
Heirlooms, 81
High horizon, 26
Highlight, 56
 softening, 86
Holes
 darkening, 71
 filling, 70
Home base, 66
Horizons. *See* High horizon; Low horizon
Hot-pressed paper, 16

I

Images
 composition. *See* Found images
 refinement. *See* Silver teapot
 transfer, 31
Ishta, 98, 99

J

Jake's Foal, 44, 45

L

Lace, demonstration, 69–71
Landscape paintings, 20
Layered drybrushing, 35
Layers
 addition, 67. *See also* Antique lace
 painting, 39
Lifting, 48–49
Light. *See* Highlight; Reflected light
 interaction. *See* Shadows
 patterns, creation, 57
 usage, 21. *See also* Natural light
Light Dance, 57
Lights, protection, 61
Local color, addition, 45. *See also* Patterned fabric; Porcelain teacup; Shells
Longhaired cat
 demonstration, 98–99
Loose washes, usage. *See* Hair in sunlight
Low horizon, 26
Luna, 18–19
Luxury Cat, 27

M

Man-made objects, usage, 21
Markers, usage, 106–107

Masking, 46–47. *See also* Glass; Halo
Masking fluid, 17
 removal, 37, 47, 49, 55, 113
 usage, 100. *See also* Drawing
Maties, 39
Middle tones, creation. *See* Hair in sunlight
Monochromatic foundation. *See* Shells
Mop brushes, usage, 111

N

Natural light, usage, 52
Natural numbers, usage, 21
Nectarines, 42
Nectarines and Cherries, 27
Nectarines and Tea, 63
 demonstration, 61–63
Negative space, usage, 23
Neutral gray, components, 60

O

Opacity, contrast. *See* Transparency
Organic objects, usage, 21

P

Painting completion. *See* Teapot
progress, 113
Paints
 blotting. *See* Pooling paint
 mixing, 63
 preparation, 66
 usage, 12
Palettes, 14
paints, placement, 14
Palm Fronds, 37
Pansies, 28
Pansy Pot II, 104, 105
Paper, 16. *See also* Cold-pressed paper;
 Hot-pressed paper; Rough paper
Paper towels, 17
Pattern Study, 108–109, 113
Patterned fabric
 demonstration, 106–107
Patterns
 combination, 110
 creation. *See* Light
 usage, 56
Patterns, 107
Pearls
 demonstration, 80–81
Pencils, 17
Peppers and Onions, 55
Perspective, change, 21
Polished wood
 demonstration, 77–79
Pooling paint, blotting, 67
Porcelain teacup
 demonstration, 82–83
Portraits, 20
Projector, usage, 31
Proportion grid, usage, 31

R

Reference photos, usage, 30, 110
Reflected light, 56
Reflections, 53

edges, softening, 78
 masking. *See* Glass
 separation, color (usage), 79
Refraction, observation, 53
Repetition, 21
Roses, 48, 49
Roses
 demonstration, 87
Rough paper, 16
Rubber cement pickup, usage, 81, 83, 94
Rule of thirds, 26

S

Scrubbing, 48–49
Sculpting, color (usage), 81
Shadows. *See* Cast shadows; Form shadow;
 Hard shadows; Soft shadows
 addition. *See* Patterned fabric
 color, determination, 56
 deepening, 42
 light, interaction, 56–57
 painting. *See* Cast shadows
 play, 57
Shapes, identification, 22
Shells
 demonstration, 95–97
Shells, 97
Shorthaired cat
 demonstration, 92–94
Side light, 52
Silver, Limes and Lace, 120–123
Silver and Apples, 25
Silver teapot
 demonstration, 75–76
Simplification, squinting (usage), 22
Soft shadows, 56
Space, usage. *See* Negative space
Still Life, 32–33
Still lifes, 21
Stippling, 43
Subject
 availability, 111
 selection, 20–21
Subtractive techniques, 48
Suffolk Cows, 26
Supplies, 17

T

Tangerines and Limes, 59
Tea Roses, 20
Tea With Daisies and Apples, 22
Teapot
 colors
 addition, 115
 strengthening, 116
 demonstration, 114–117
 painting, completion, 117
 texture building, 115
 strengthening, 116
Texture
 addition. *See* Concrete planter; Teapot
 combination, 110
 strengthening. *See* Teapot
 variation, 27

Thirds, rule. *See* Rule of thirds
Three Bosc Pears, 25
Tone, setting, 75
Transfer paper, 17
Transparency, opacity (contrast), 13
Tropical Fruit, 28

U

Underpainting, 44–45. *See also* Apples

V

Value contrast, 58
 assessment, 42
Value scales, 58
Values, deepening. *See* Concrete planter
Variegated washes, 34
Viewer, engaging, 29
Visual echo, 24
Volume, establishing, 62

W

Warm colors, cool colors (contrast), 59
Warm gray, contrast. *See* Cool gray
Washes, 34, 102. *See also* Flat washes;
 Graduated washes; Variegated washes;
 Wet-in-wet wash; Wet-on-dry wash
 application, 61
 painting, 66. *See also* Concrete planter
 usage. *See* Hair in sunlight
Wet-in-wet technique, 38–39
Wet-in-wet wash, 62, 80, 96, 99
Wet-on-dry detail technique, 77
Wet-on-dry strokes, 37, 47
Wet-on-dry technique, 36–37, 83
 detail, addition, 39
Wet-on-dry wash, 101
White foam board, usage, 30
Wool Rug, 43

Learn to paint stunning watercolors
with these other fine North Light Books!

Every truly great watercolor painting hinges on the qualities of light and texture. James Toogood shows you exactly how to use these elements to add more drama, depth and believability to your work. Whether you're a beginning or advanced artist, you will appreciate the wealth of instruction in this book. This is a must-have book for your watercolor collection.

ISBN 1-58180-439-3, hardcover, 128 pages, #32657-K

Beautifully illustrated and superbly written, this wonderful guide is perfect for watercolorists of all skill levels! Gordon MacKenzie distills over thirty years of teaching experience into dozens of painting tricks and techniques that cover everything from key concepts, such as composition, color and value, to fine details, including washes, masking and more.

ISBN 0-89134-946-4, hardcover, 144 pages, #31443-K

Elizabeth Kincaid invites you to follow her proven techniques for painting dazzling scenes drenched in color. Her beautiful flowers, foliage and landscapes will have you eager to create your own – and you will with easy-to-follow step-by-step instructions that take the mystery out of composition, color, light and shadow and a practical guide to masking and glazing. You're newly trained eyes will be able to visualize before painting and better perceive abstract form, value, line and color.

ISBN 1-58180-468-7, hardcover, 128 pages, #32731-K

There's nothing more inspiring than a glimpse into the artistic lives of the country's best contemporary watercolor painters. *Splash 8: Watercolor Discoveries* showcases over 130 paintings by almost 100 top artists from around the country providing advice with every piece of artwork covering both practical and creative breakthroughs made by the featured artists that you can apply to your work.

ISBN 1-58180-442-3, hardcover, 144 pages, #32690-K

These and other fine North Light books are available at your local art & craft retailer, bookstore, online supplier or by calling 1-800-448-0915.